AMP

ASIAN MALE PORTRAITS

2

2016-2018

WEST PHILLIPS

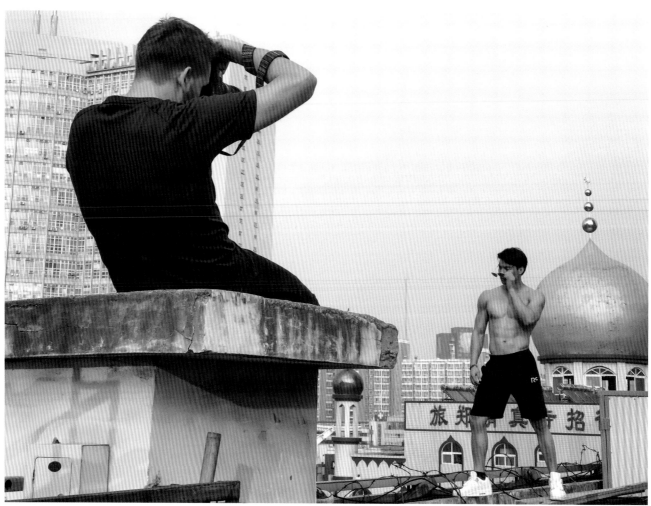

Behind the scenes:
Yan
Zhengzhou, China
2017

began photography as a hobby rather unexpectedly in the fall of 2009 while living in New York City. I had never taken any sort of photography class, but found this growing inspiration in the environment around me and wanted to capture it as best I could. I had a new camera, some really vague ideas and absolutely no direction. I knew I wanted to photograph the people in my life at the time, so my first few subjects were people I had close relationships with and who inspired me in one way or another. In the spring of 2010 I moved to San Francisco - what I consider to really be the starting point of my photography career. While working my office job, I used my free time to seek out new subjects for my budding art. I can remember how awkward and insecure I felt at the beginning, having to convince (beg) people to let me photograph them. I felt the brunt of rejection more times than I care to admit! The more photoshoots I did, the more confident I became and this newfound passion grew stronger with each one.

I noticed from the very beginning a clear lack of Asian male models in western media. My early interest in photographing Asian males wasn't to make any sort of statement, but rather to capture an image and look I found appealing. As my work and experience grew, so did my exposure. While most of the comments and feedback I received were encouraging and supportive, I was shocked by the number of people who would blatantly tell me my photos would be better if the models weren't Asian. It was these negative comments that I have to thank for putting me and my art on the path it is today.

This volume serves as a chronological collection of some of my work from the past 2 years to the present, 2016 - 18. Spanning several countries, the models in the following pages represent not only my growing and changing art, but also a personal glimpse into where I've been and where I'm going. Through close friends, acquaintances, professional relationships as well as more intimate relationships, I hope that these selected photos do justice to some of the incredible people I've been fortunate enough to know and work with. Without them, none of this would be possible.

West Phillips

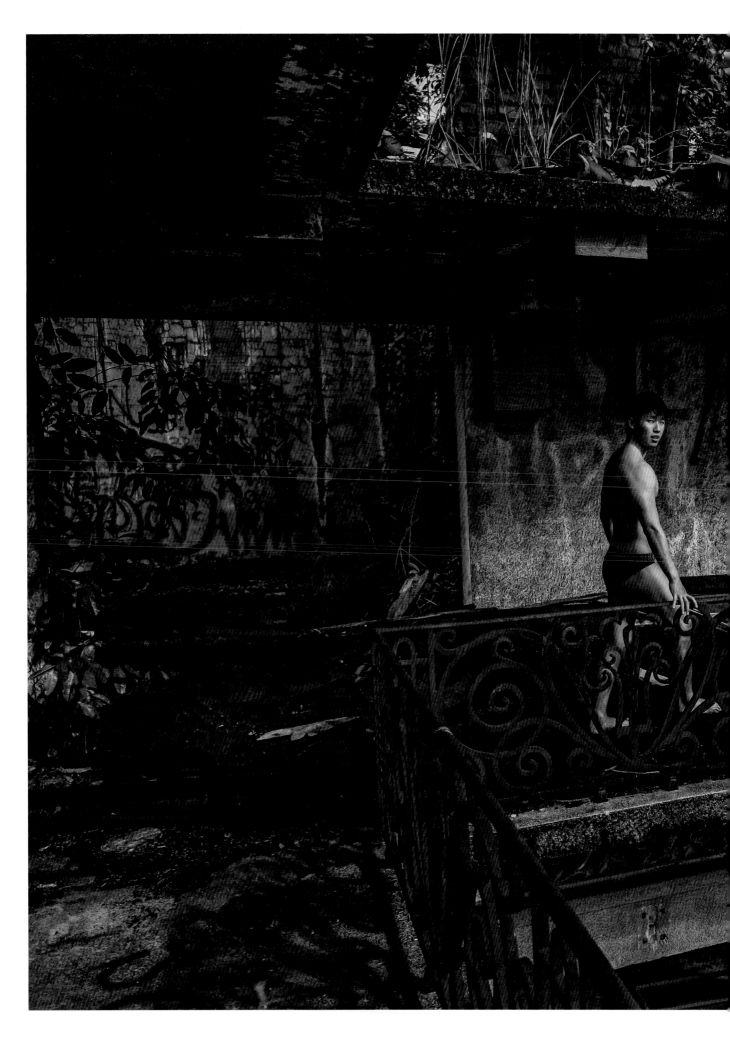

Clarence
Singapore
2016

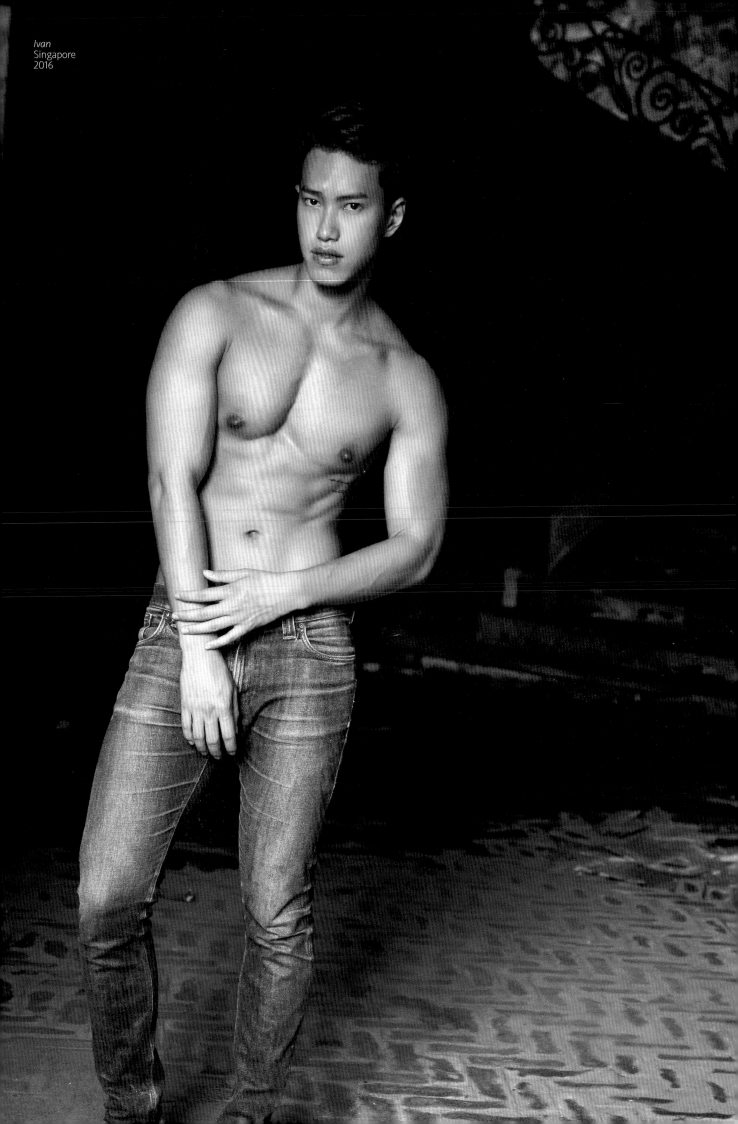

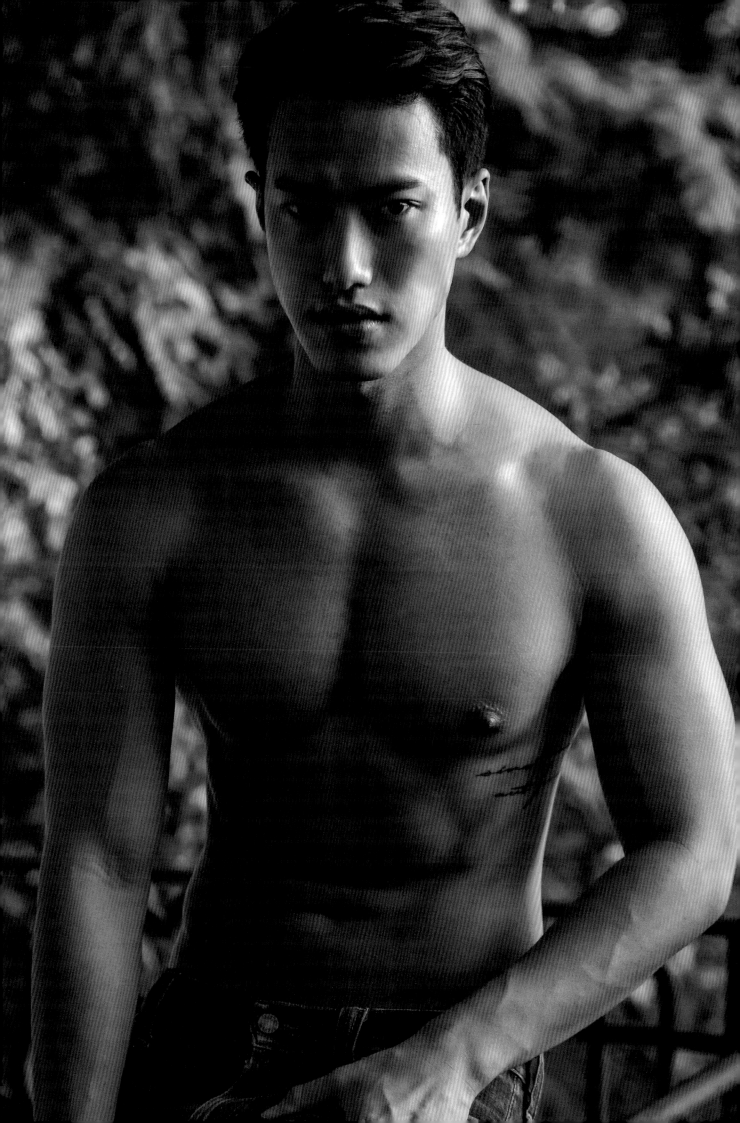

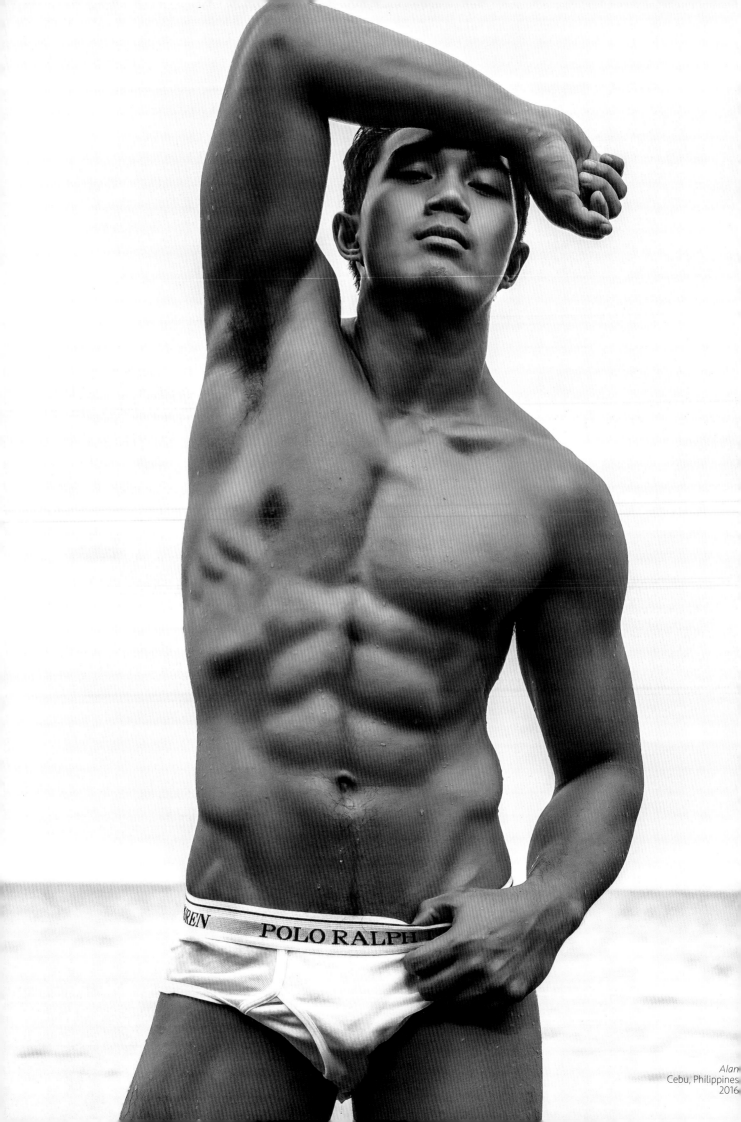

Alan
Cebu, Philippines
2016

Pilipinas

Thanks mostly to social media, my photography in the Philippines seemed to just explode overnight. In 2016 I made two separate trips to the islands to photograph some fantastic Pinoy guys. I am incredibly grateful to the enthusiasm and support I've received there!

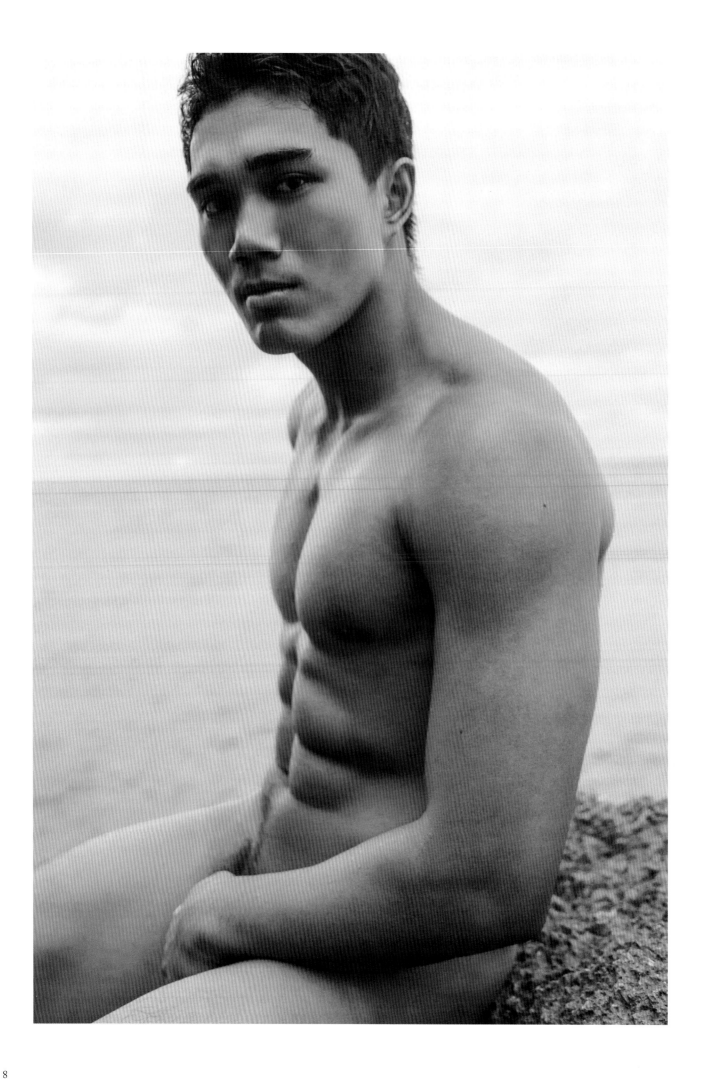

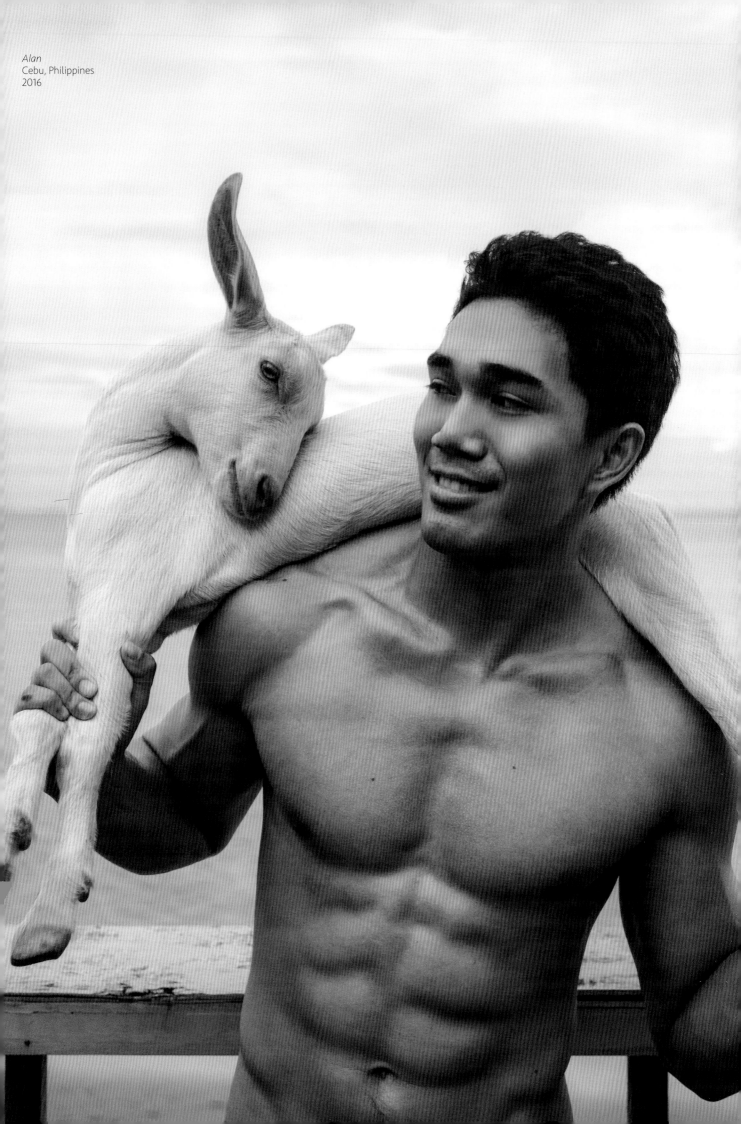

Alan
Cebu, Philippines
2016

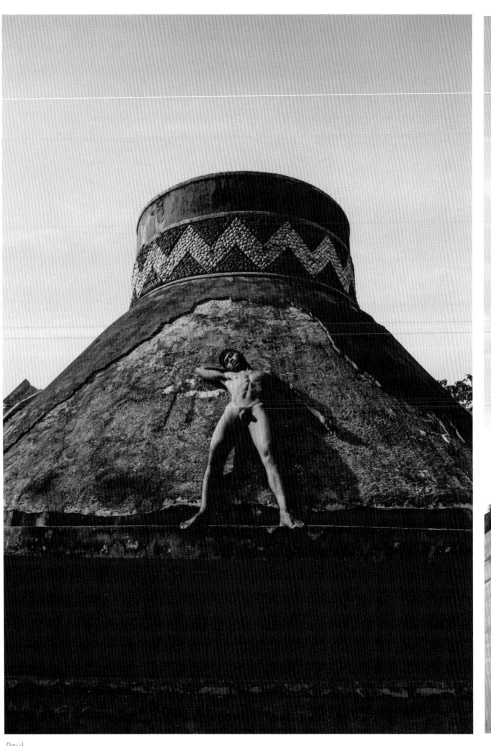

Paul
Bohol, Philippines
2016

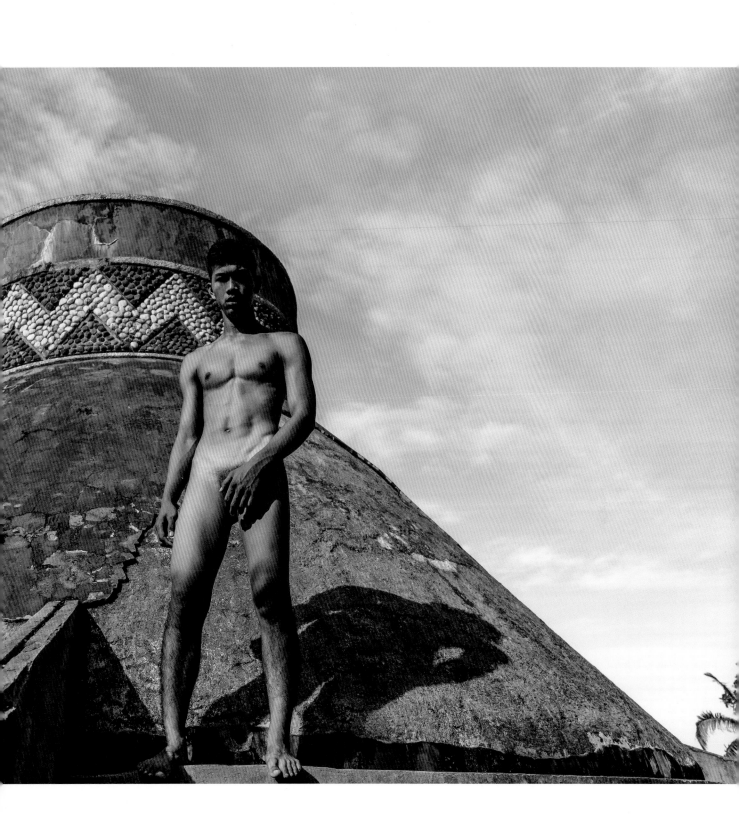

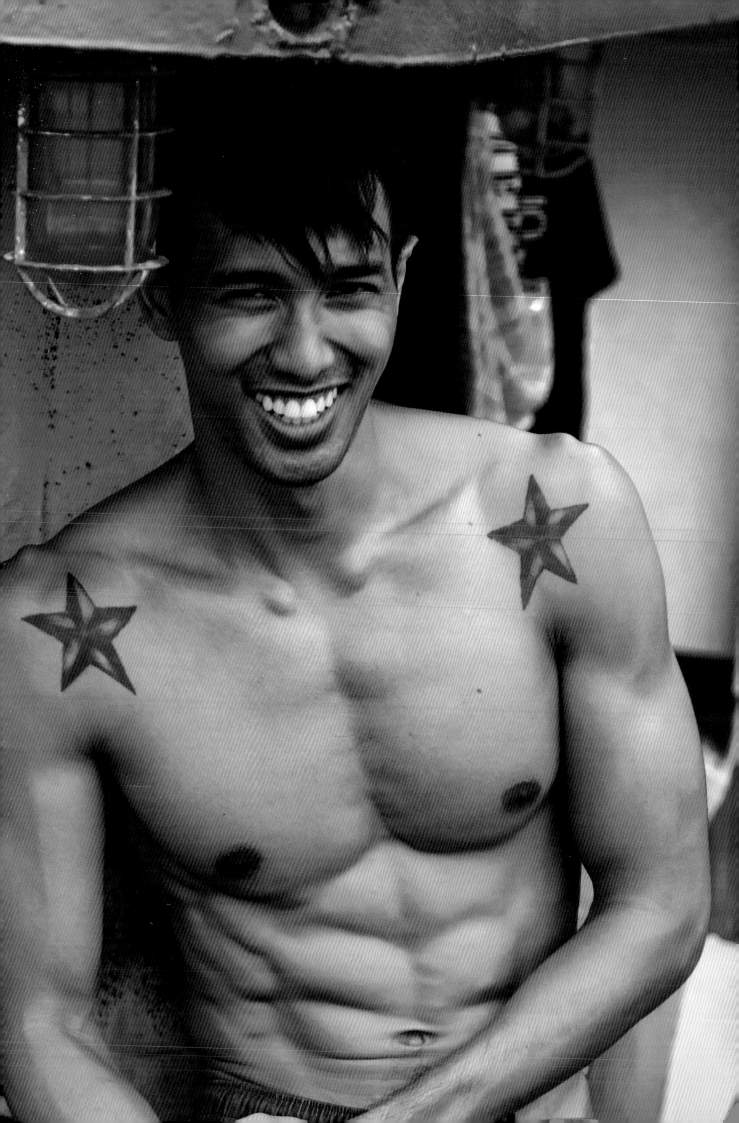

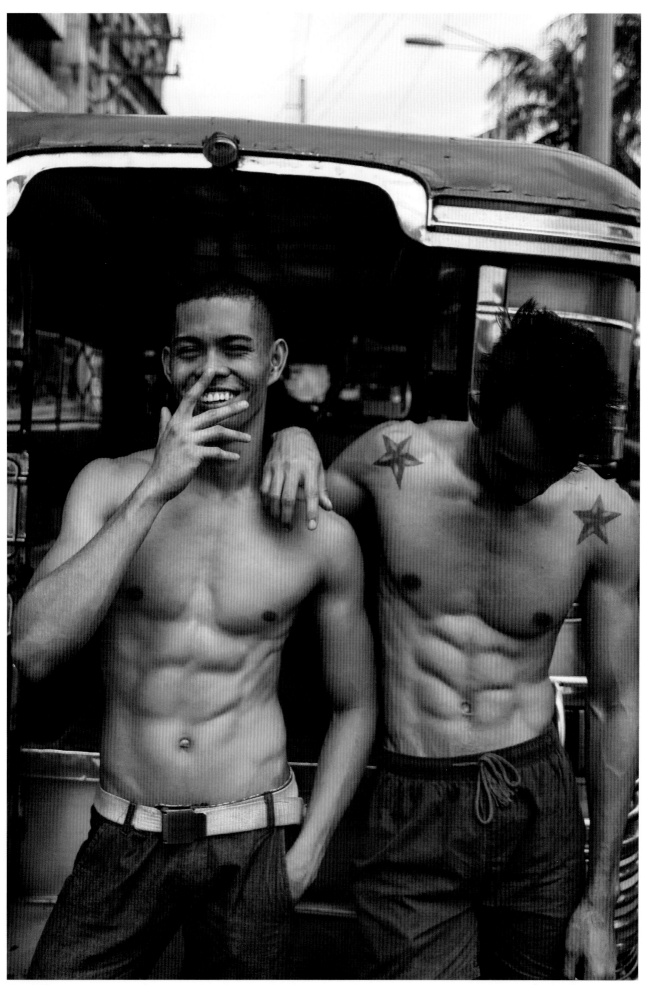

Mark & Chax
Manila, Philippines
2016

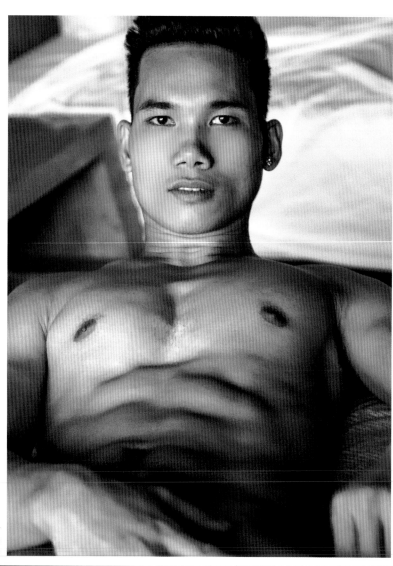

Jezer
Cebu, Philippines
2016

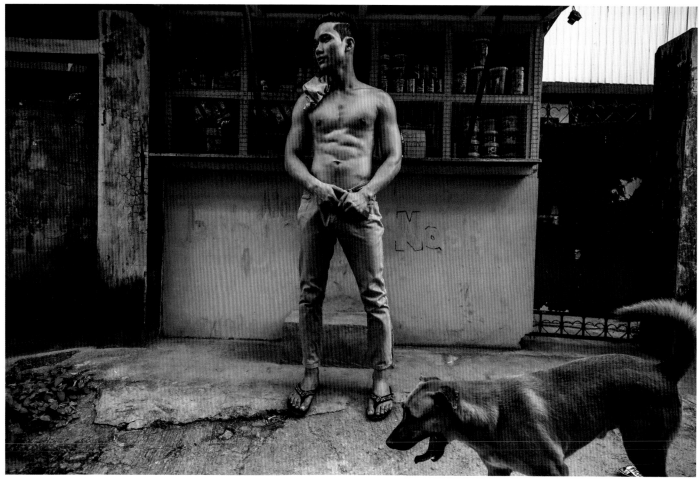

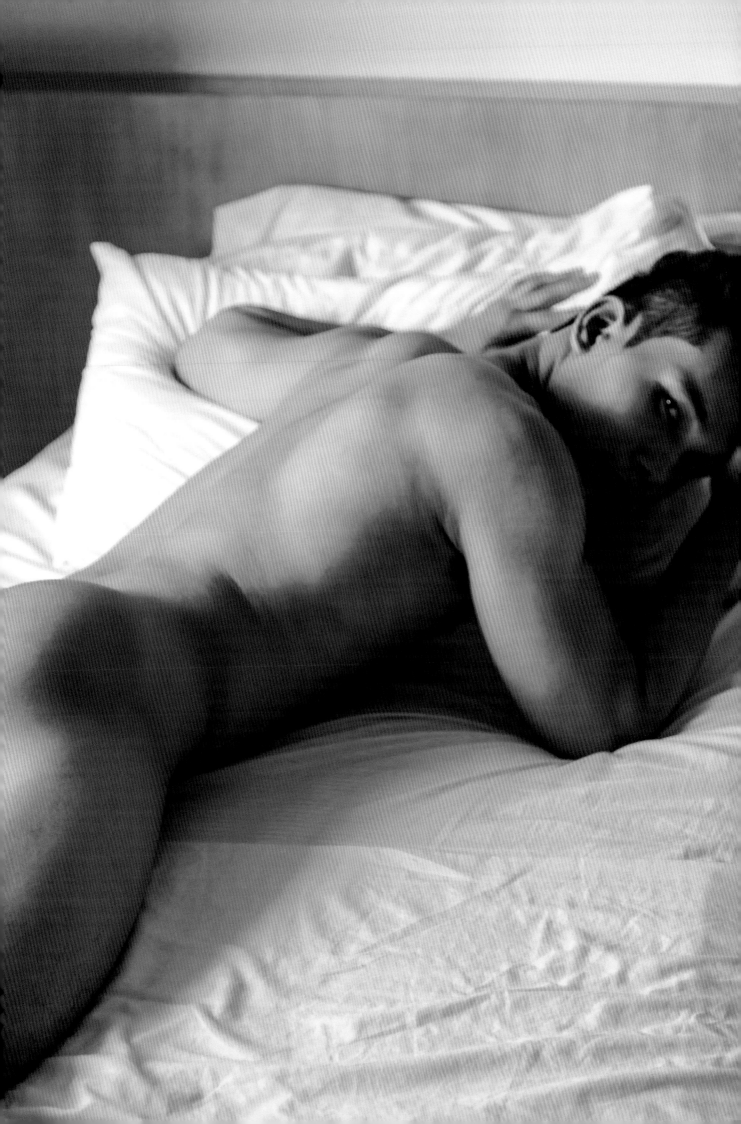

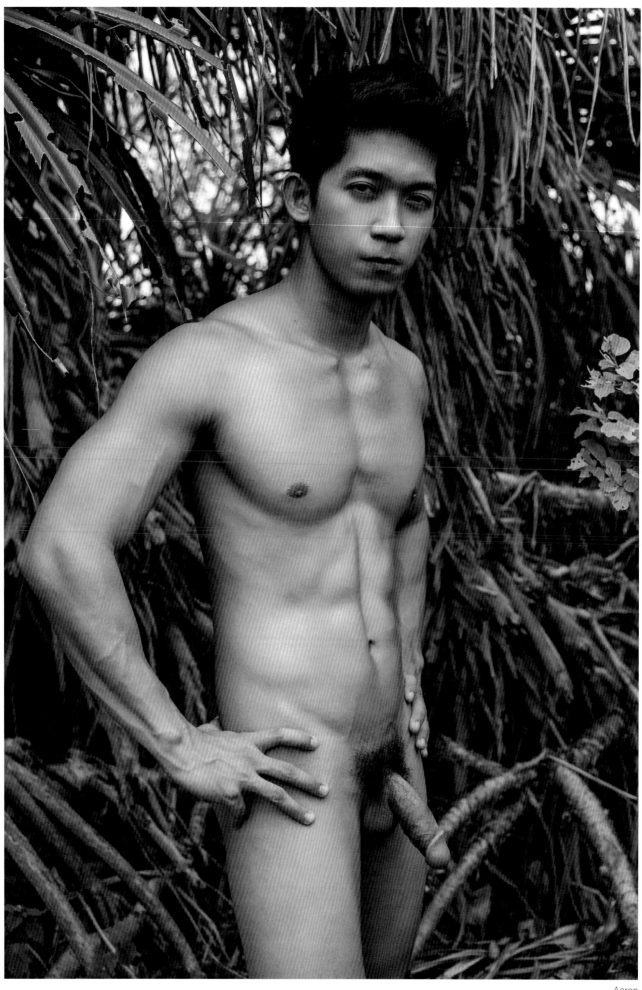

Aaron
Cebu, Philippines
2016

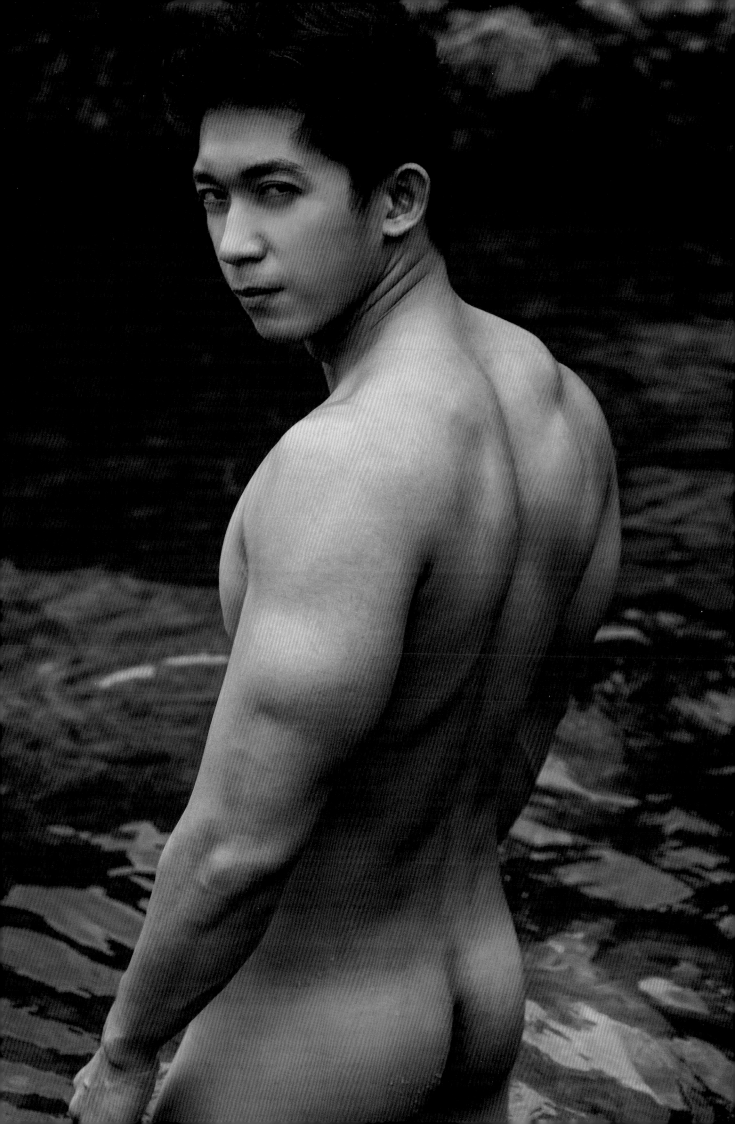

Tristan
Tuguegarao, Philippines
2016

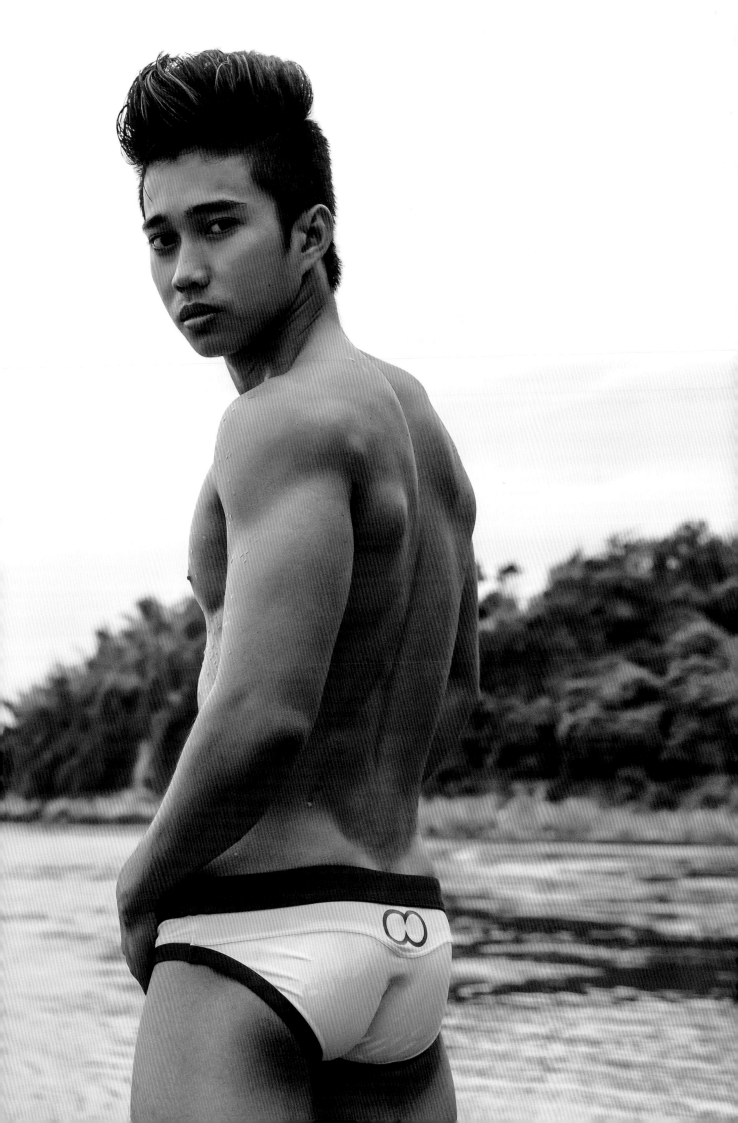

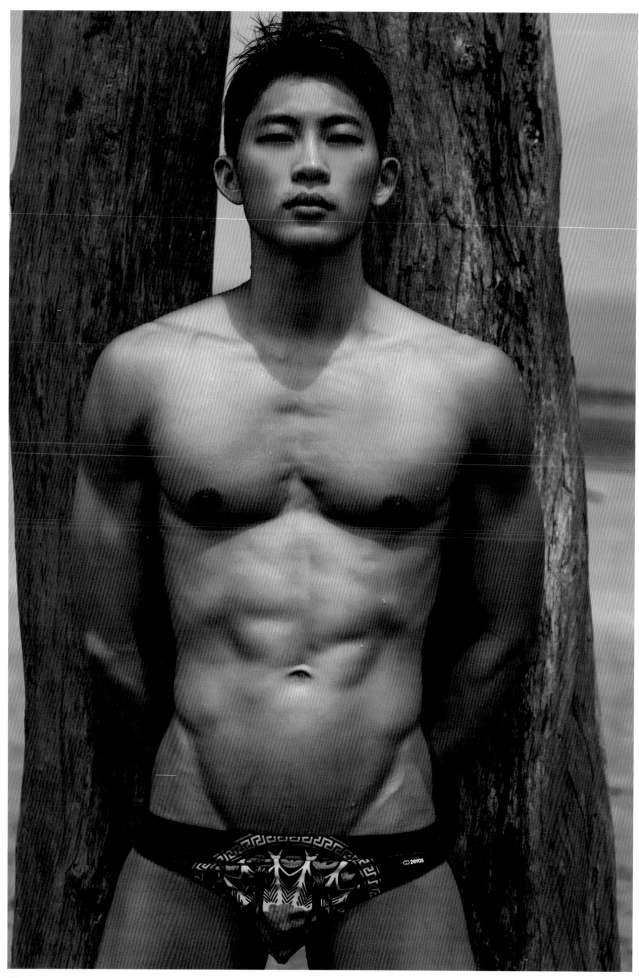

Gino
Taipei, Taiwan
2016

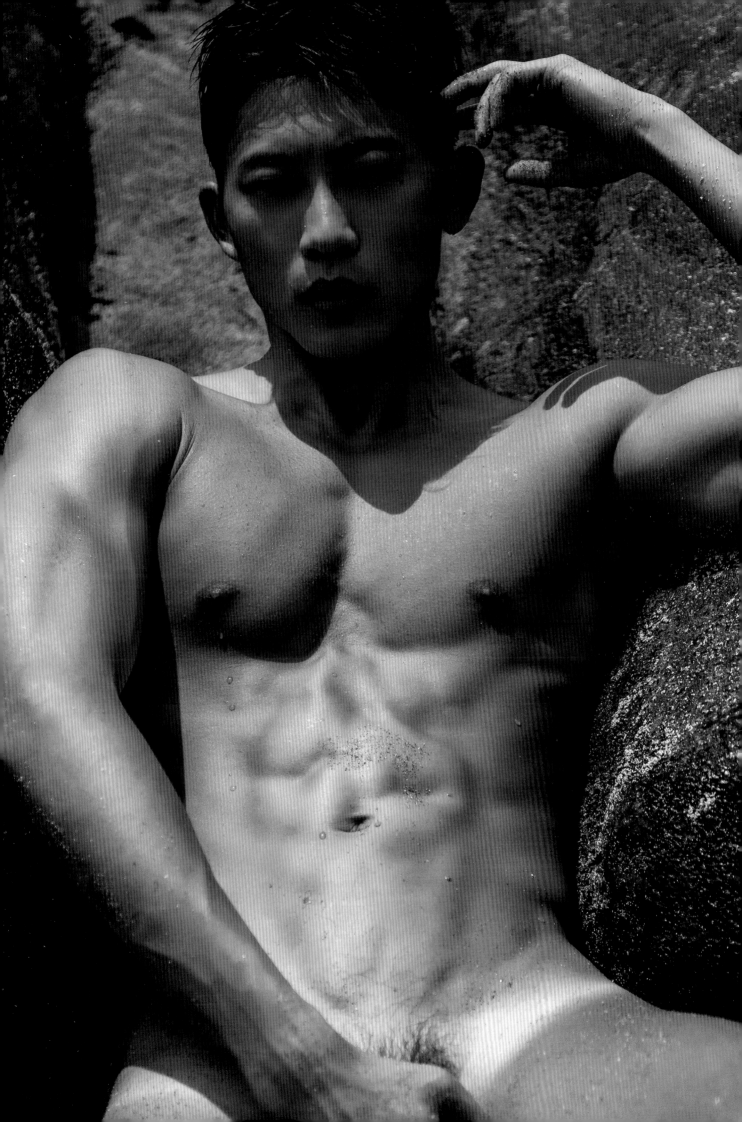

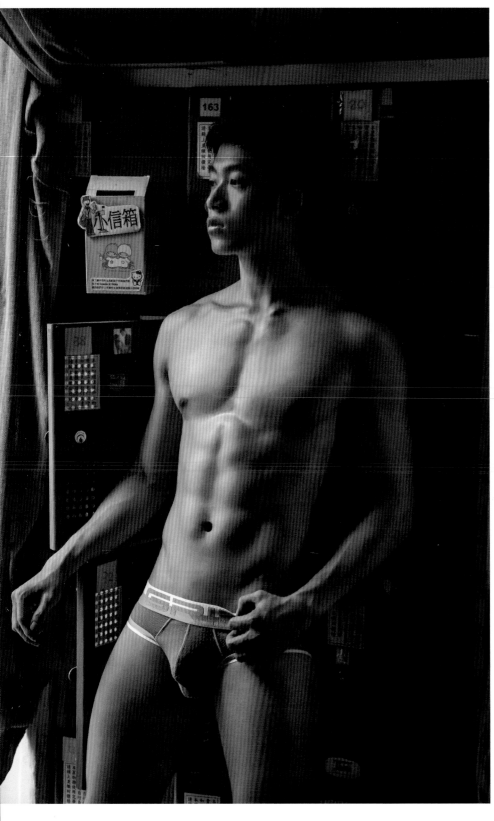

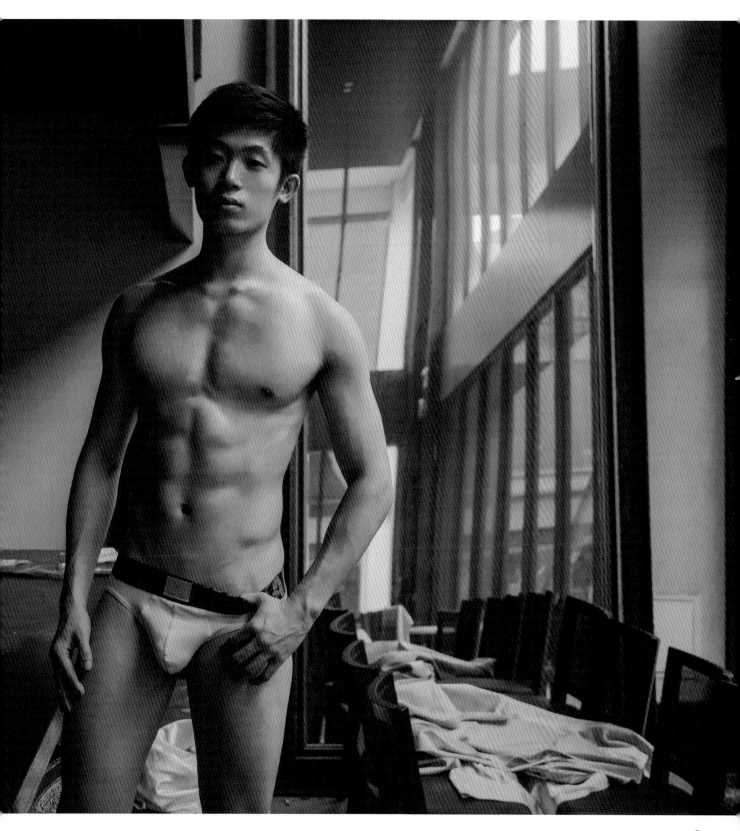

Reese
Taipei, Taiwan
2016

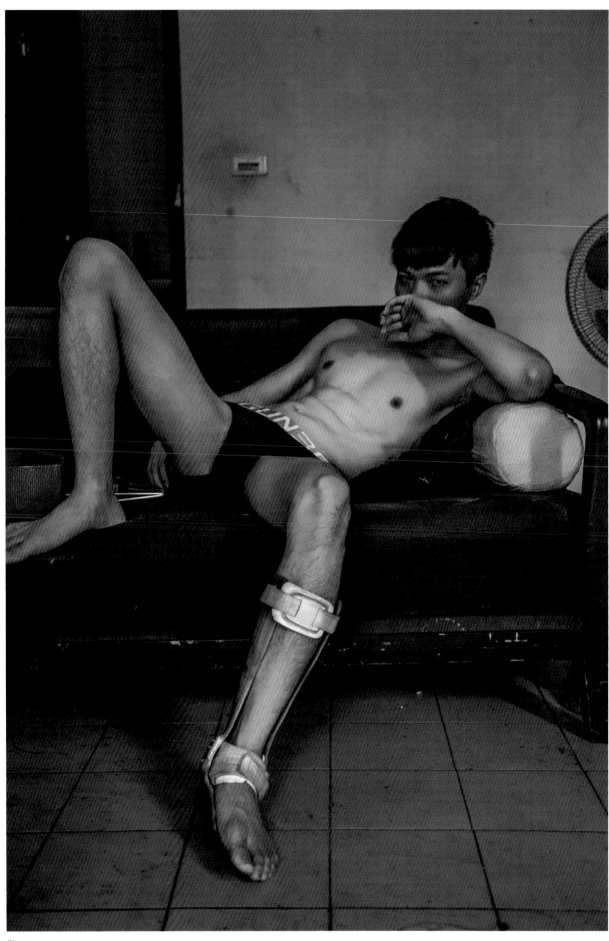

Cheng
Taipei, Taiwan
2016

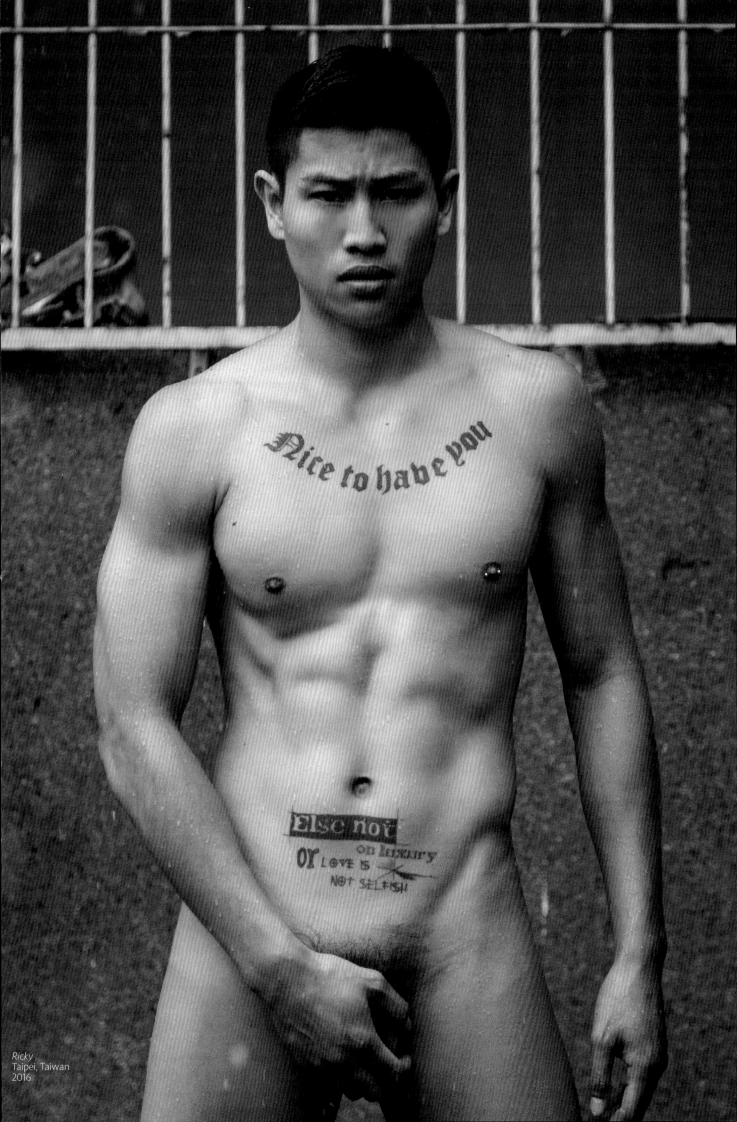

Ricky
Taipei, Taiwan
2016

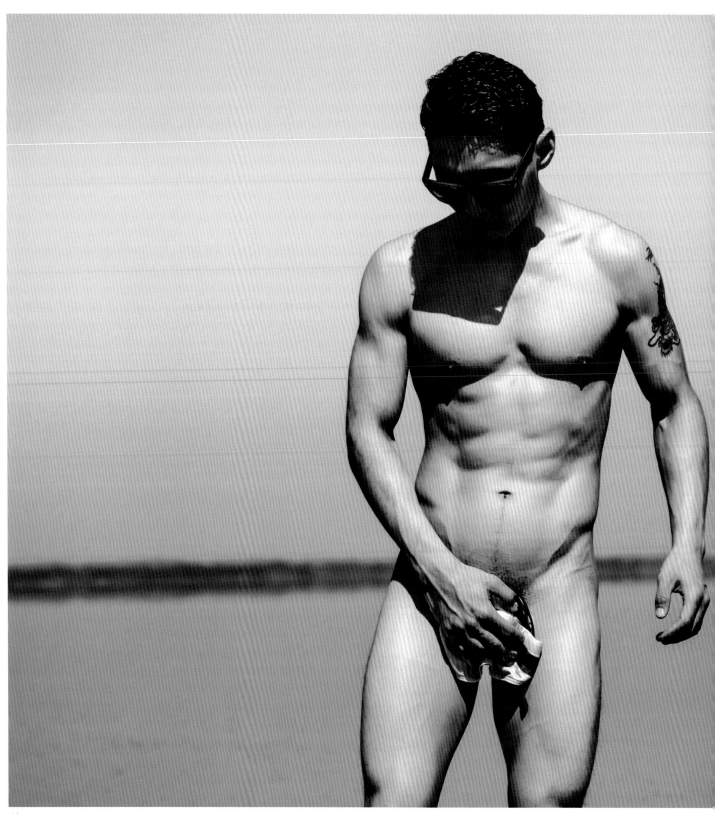

Alta
Northern California, USA
2016

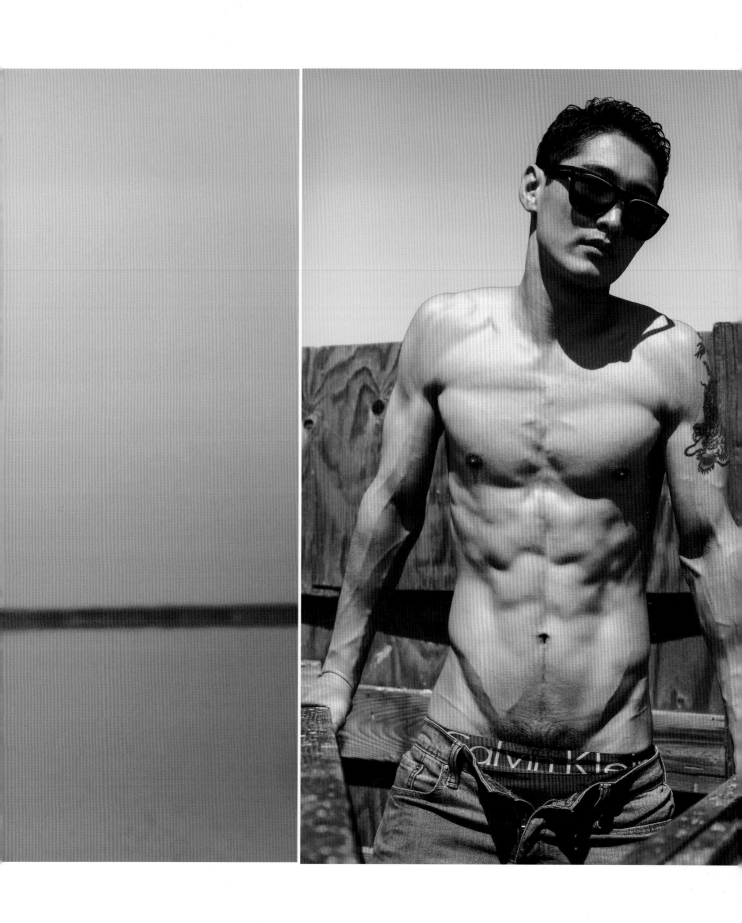

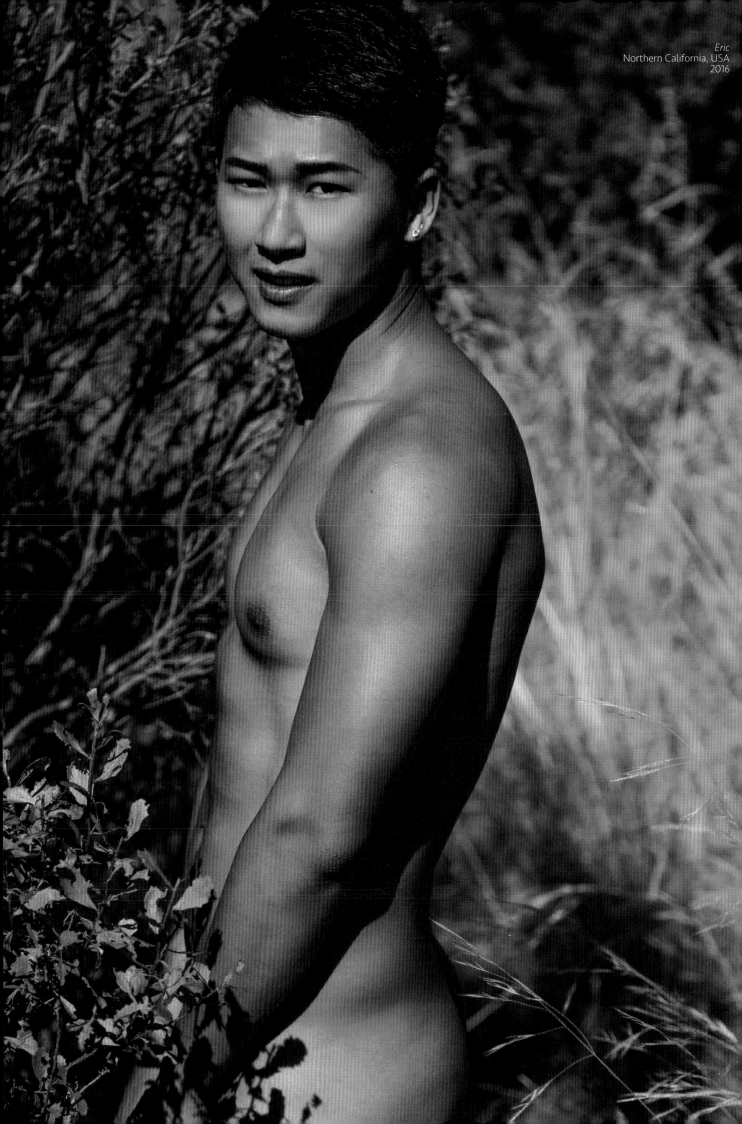

Eric
Northern California, USA
2016

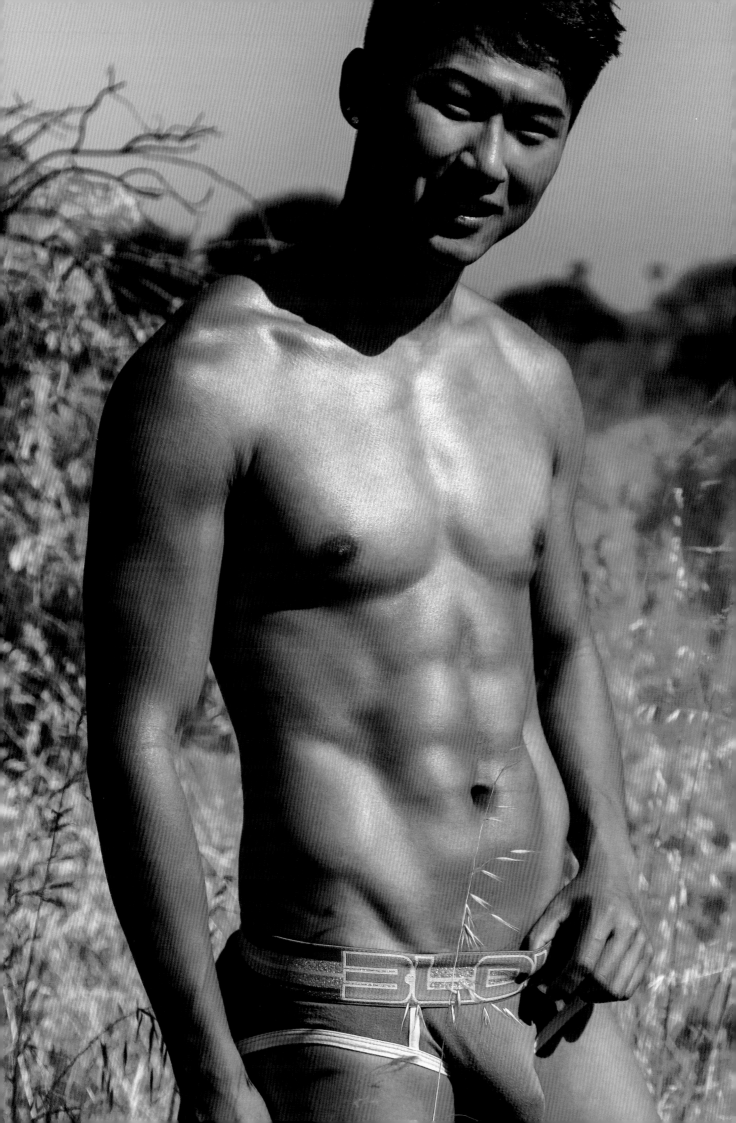

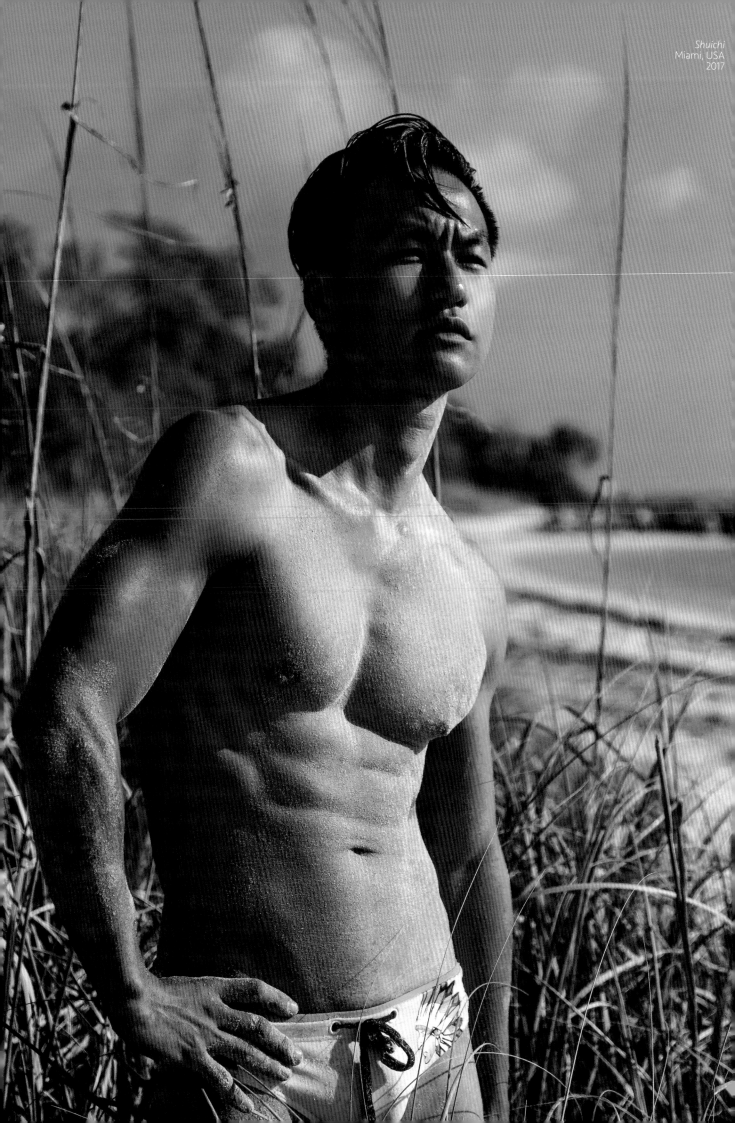

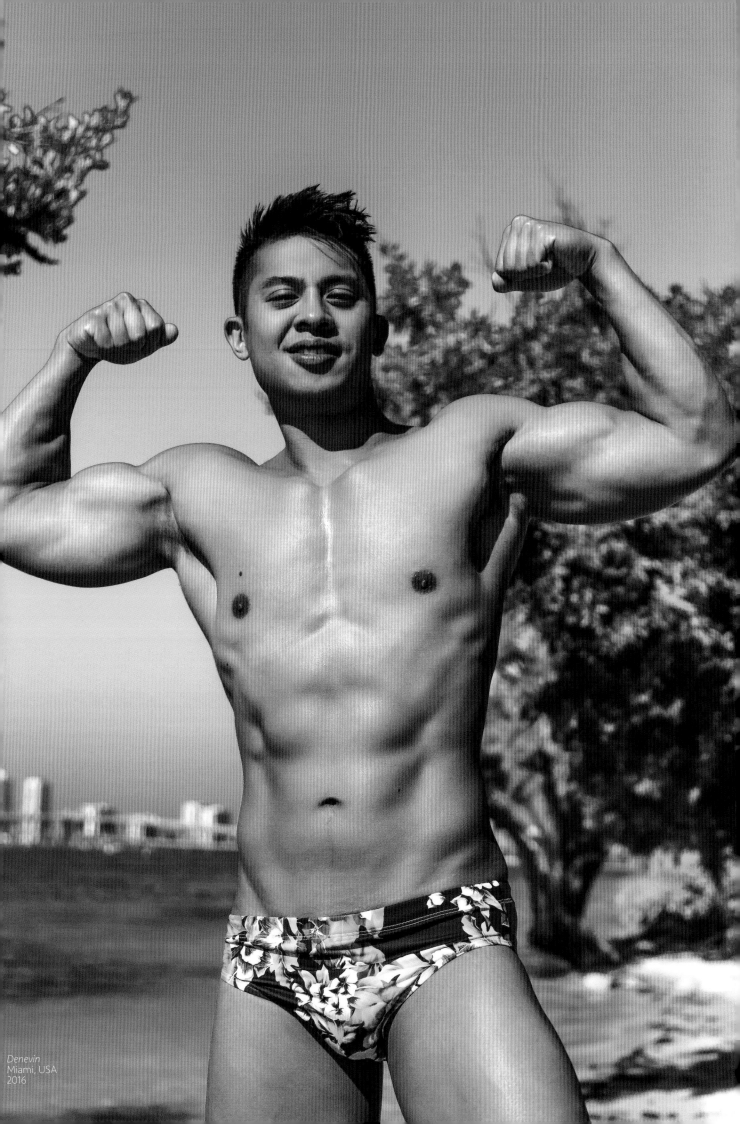

Denevin
Miami, USA
2016

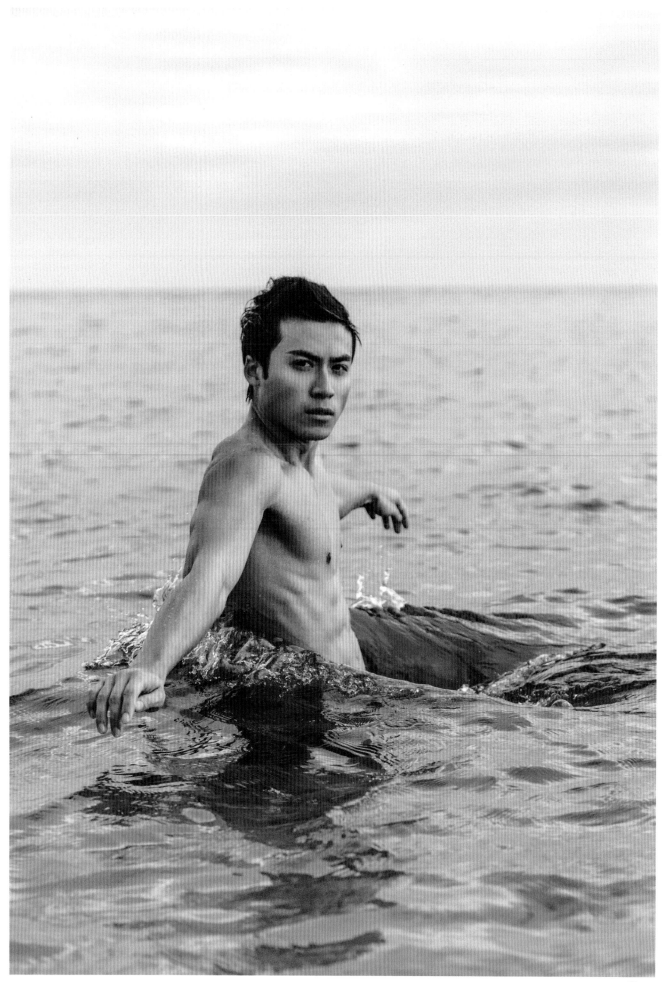

Cletus
Miami, USA
2017

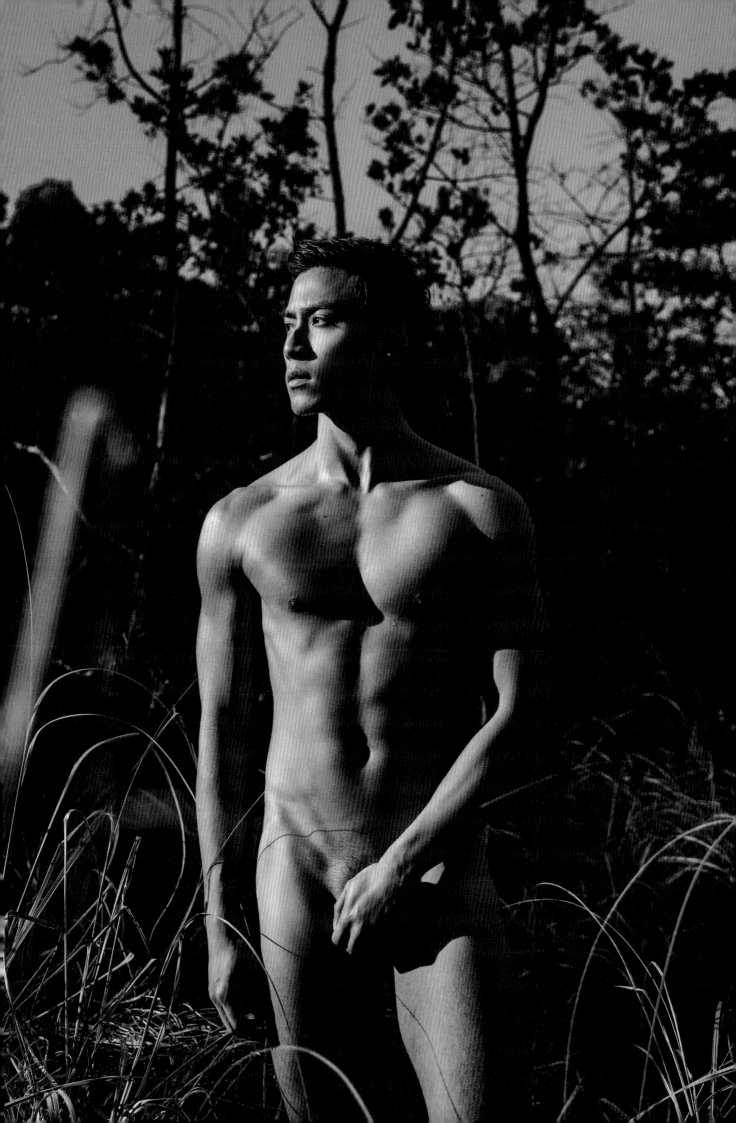

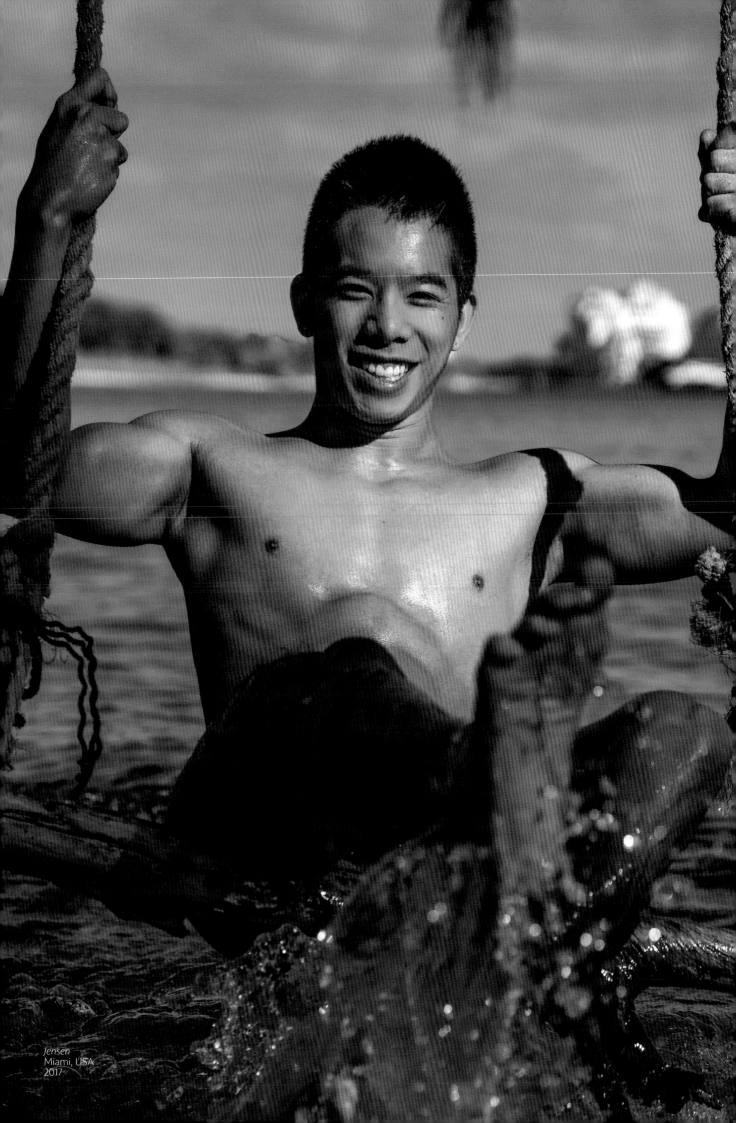

Jensen
Miami, USA
2017

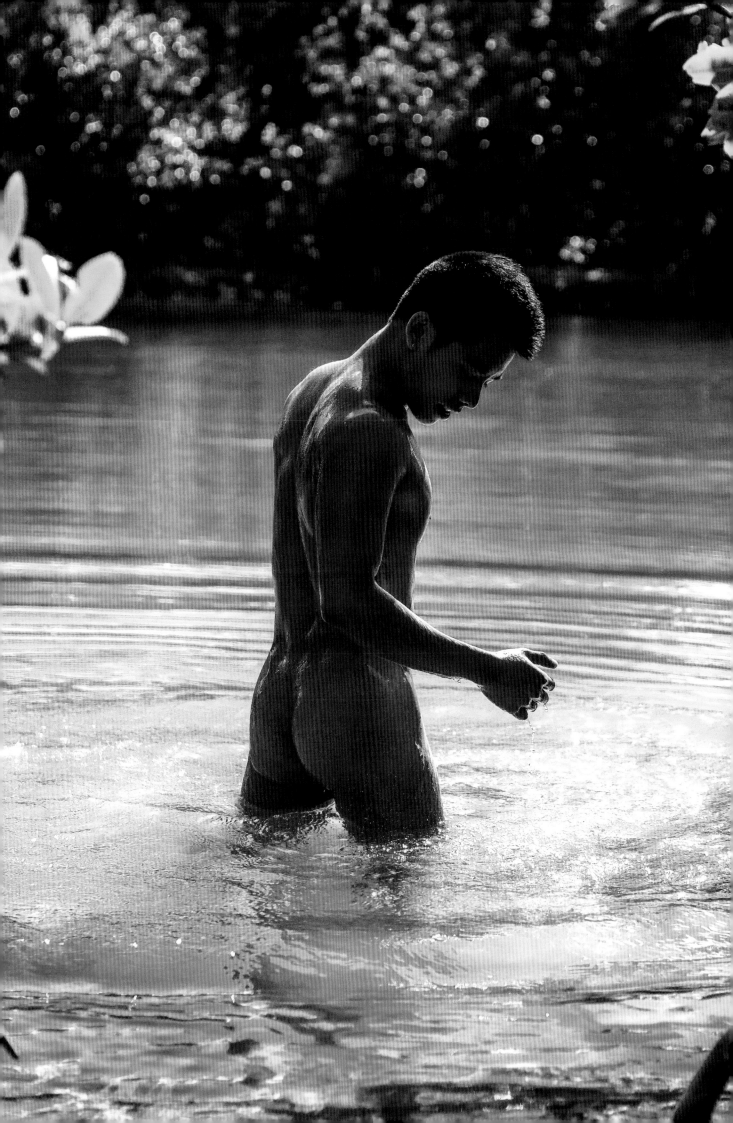

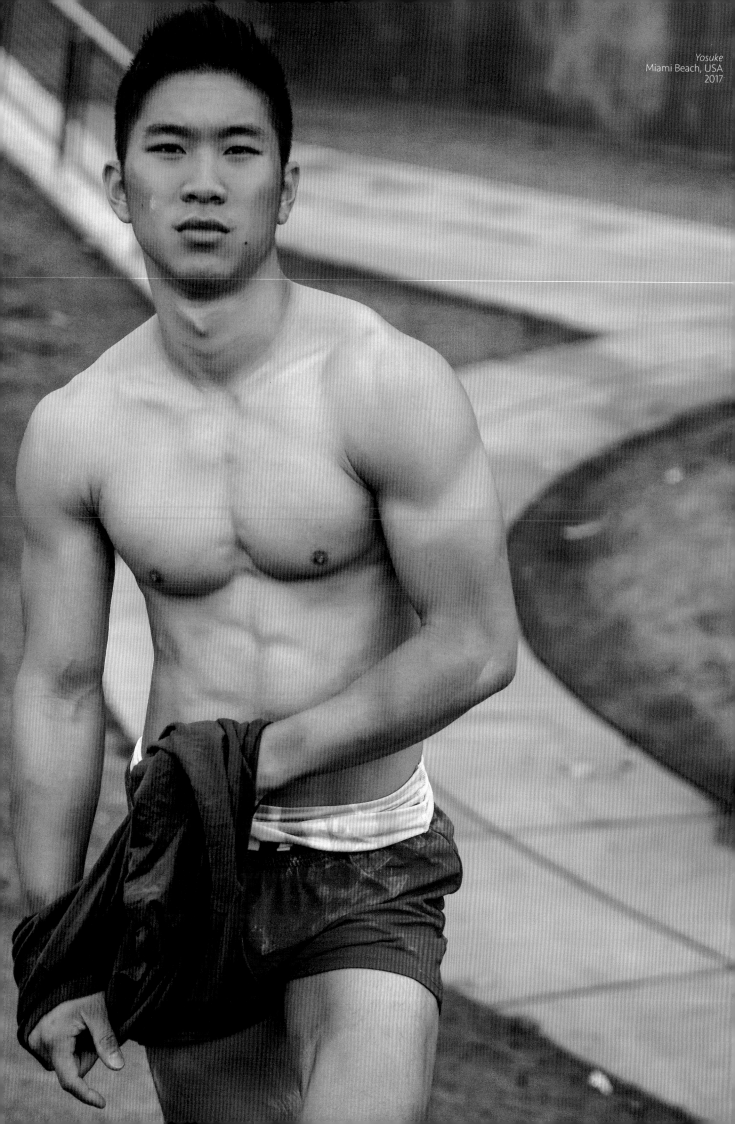

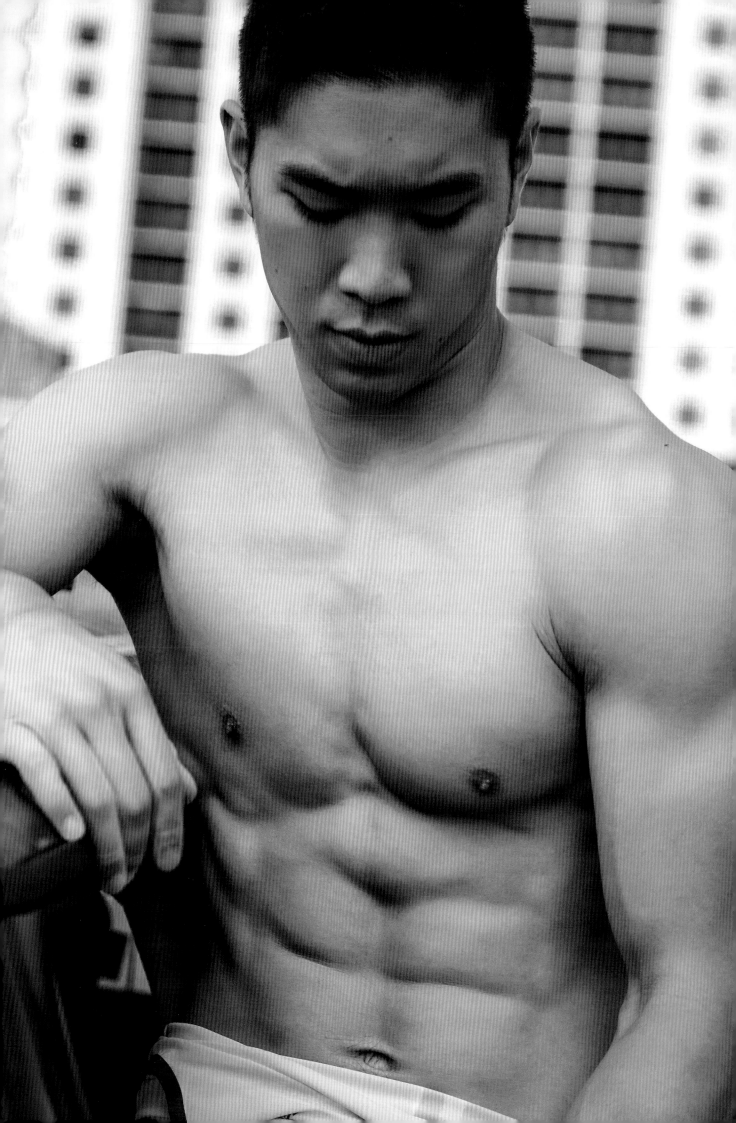

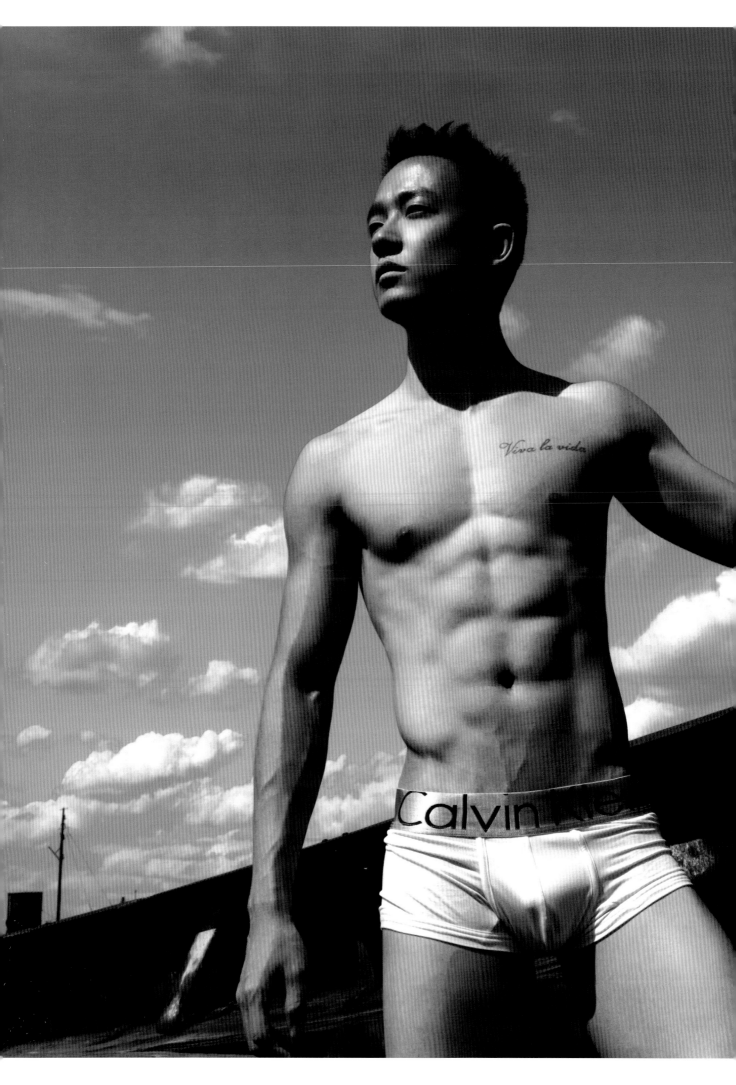

Shu
New York, USA
2017

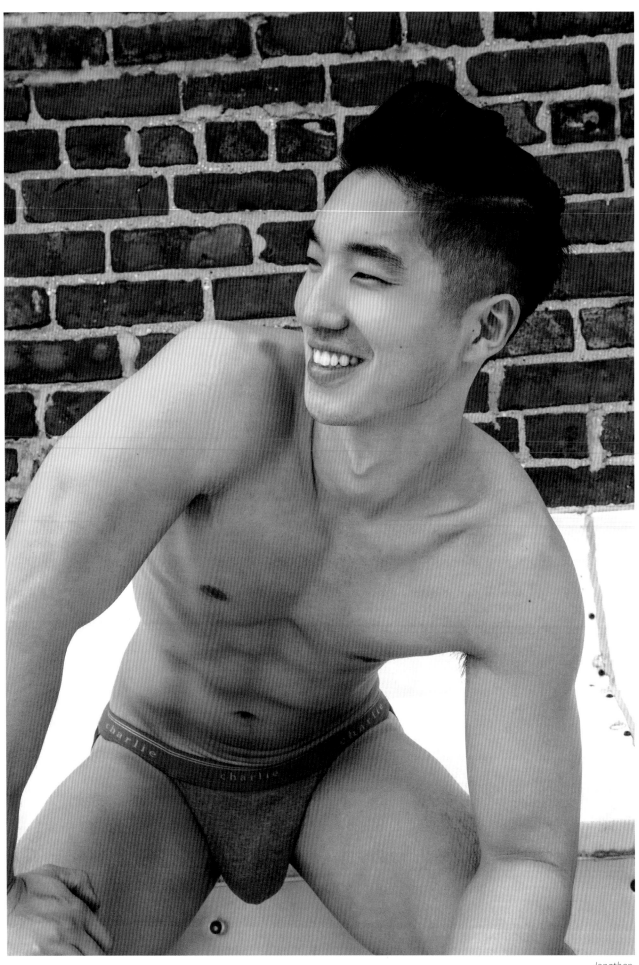

Jonathan
New York City, USA
2017

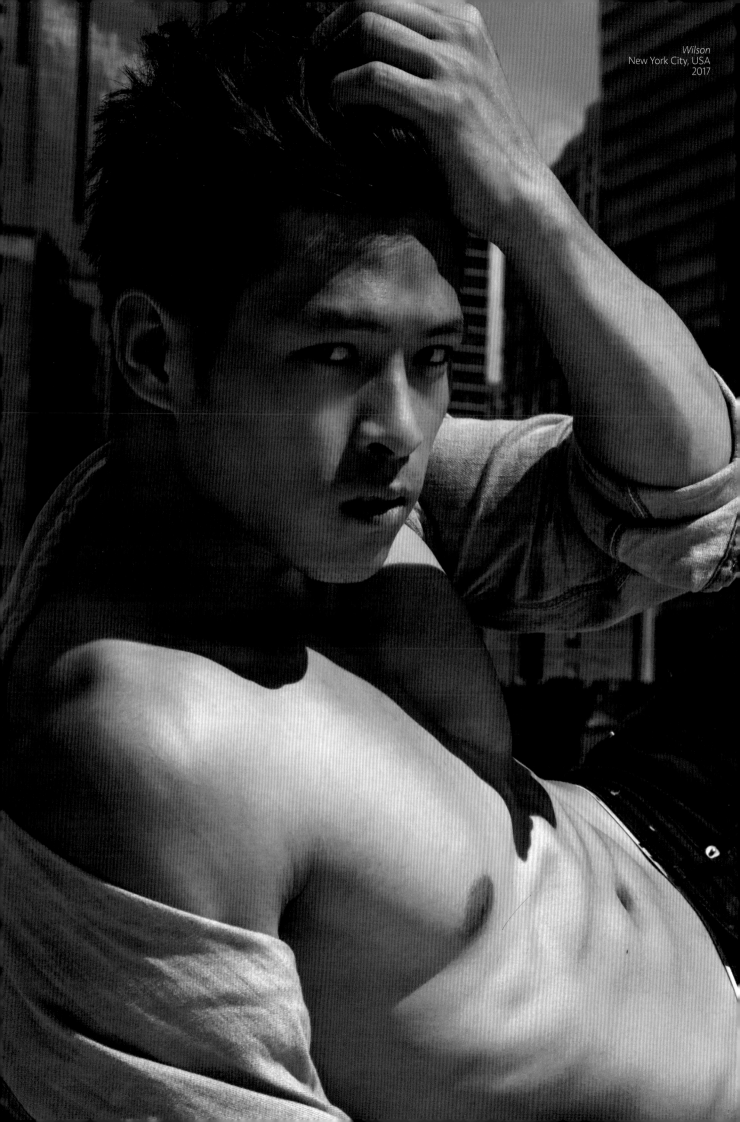

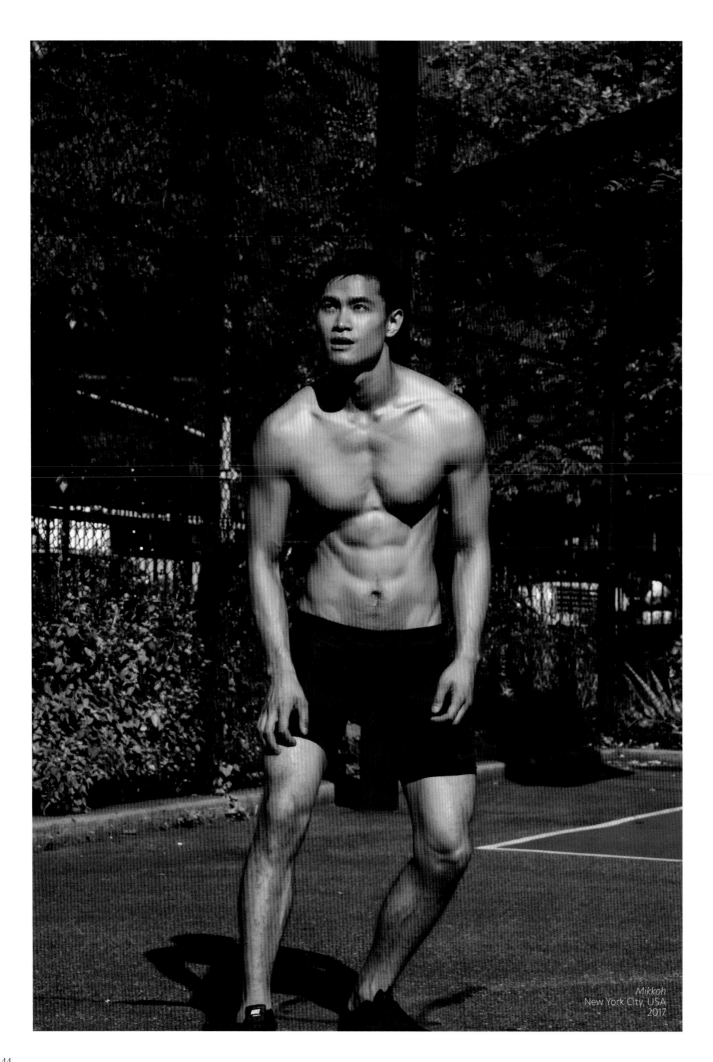

Mikkoh
New York City, USA
2017

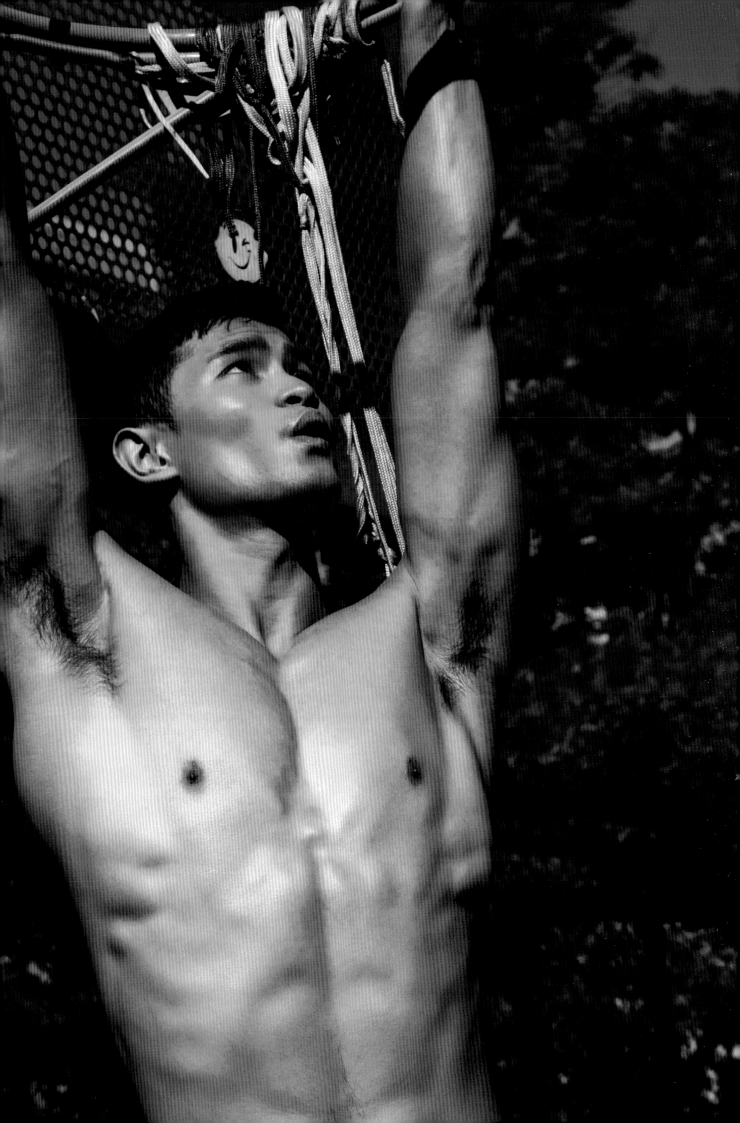

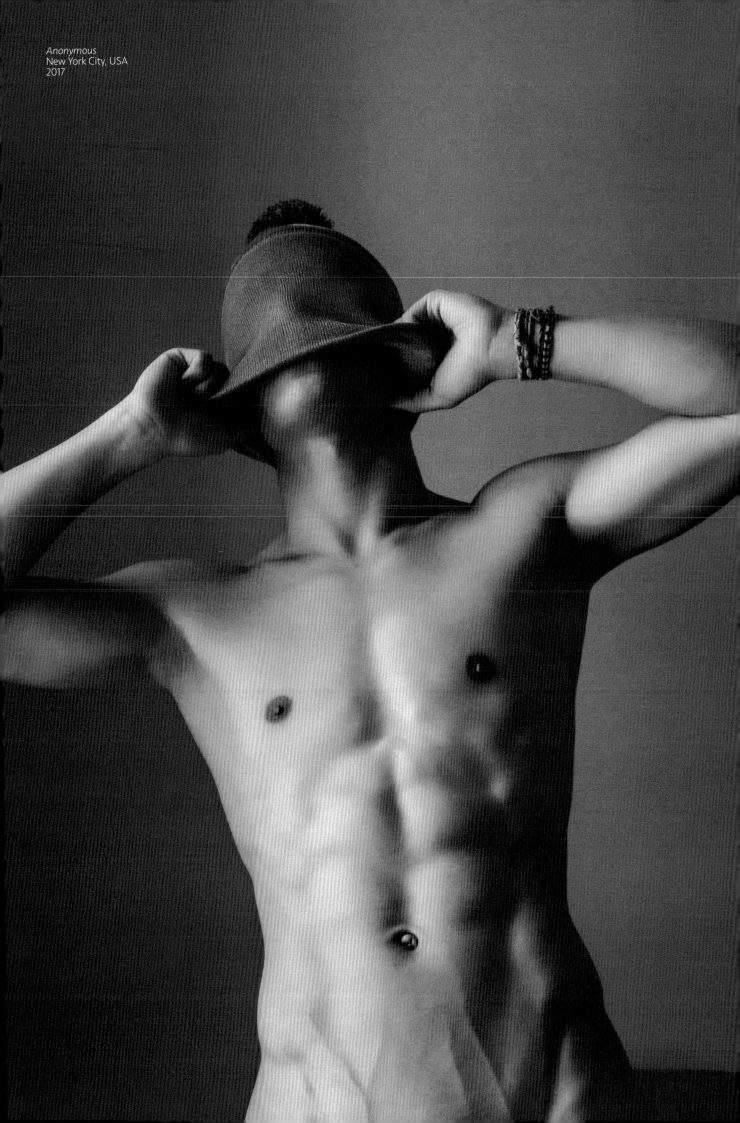

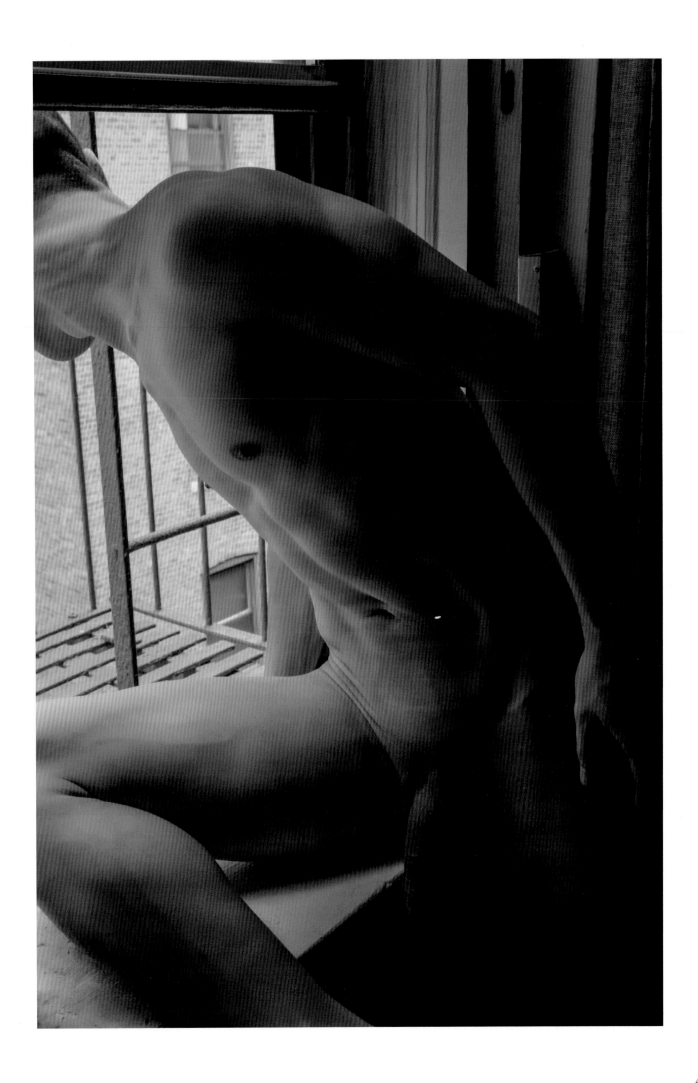

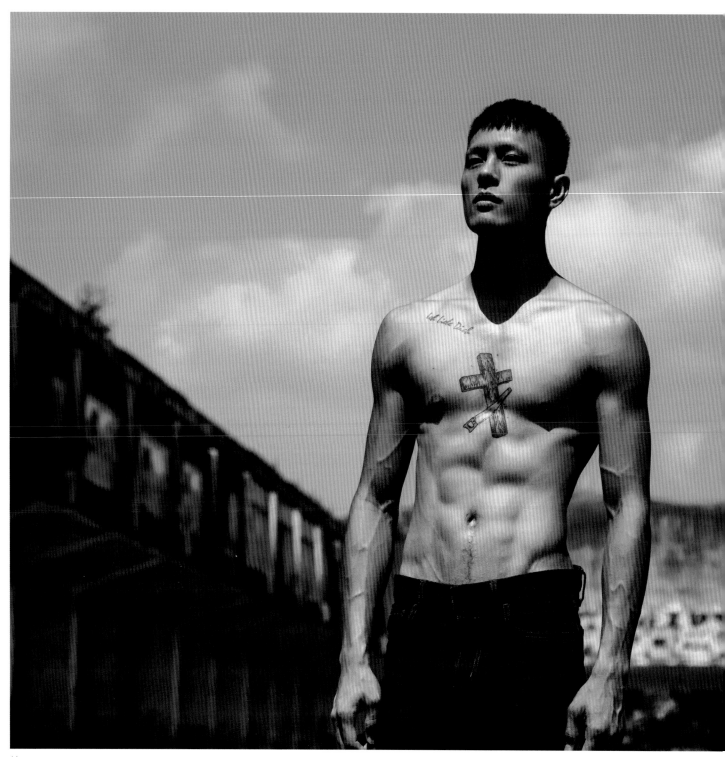

Liou
Taipei, Taiwan
2017

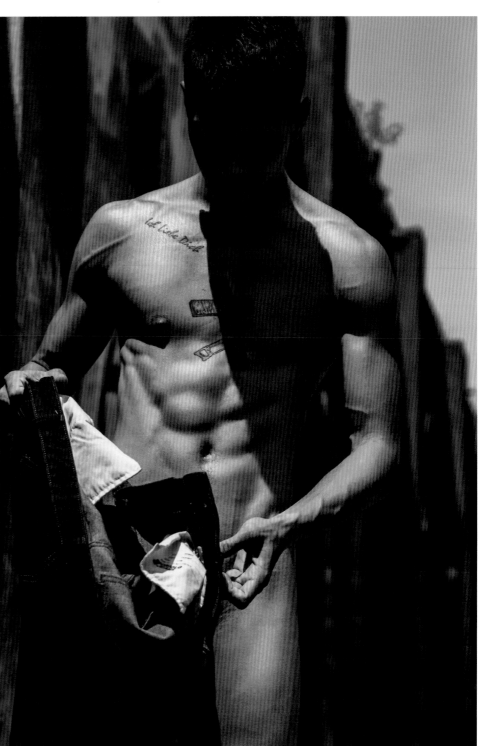

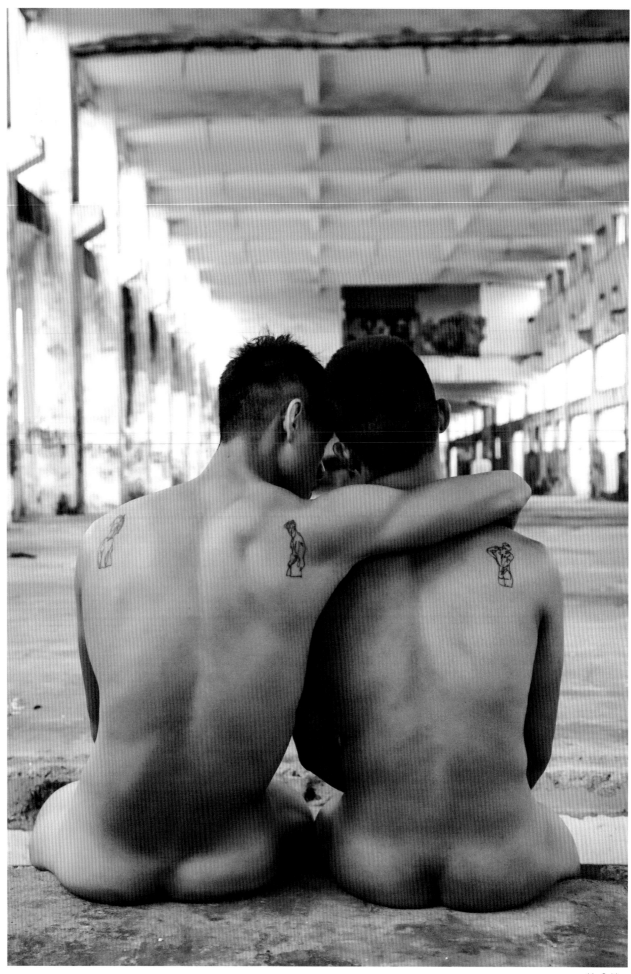

Liu & Liou
Taipei, Taiwan
2017

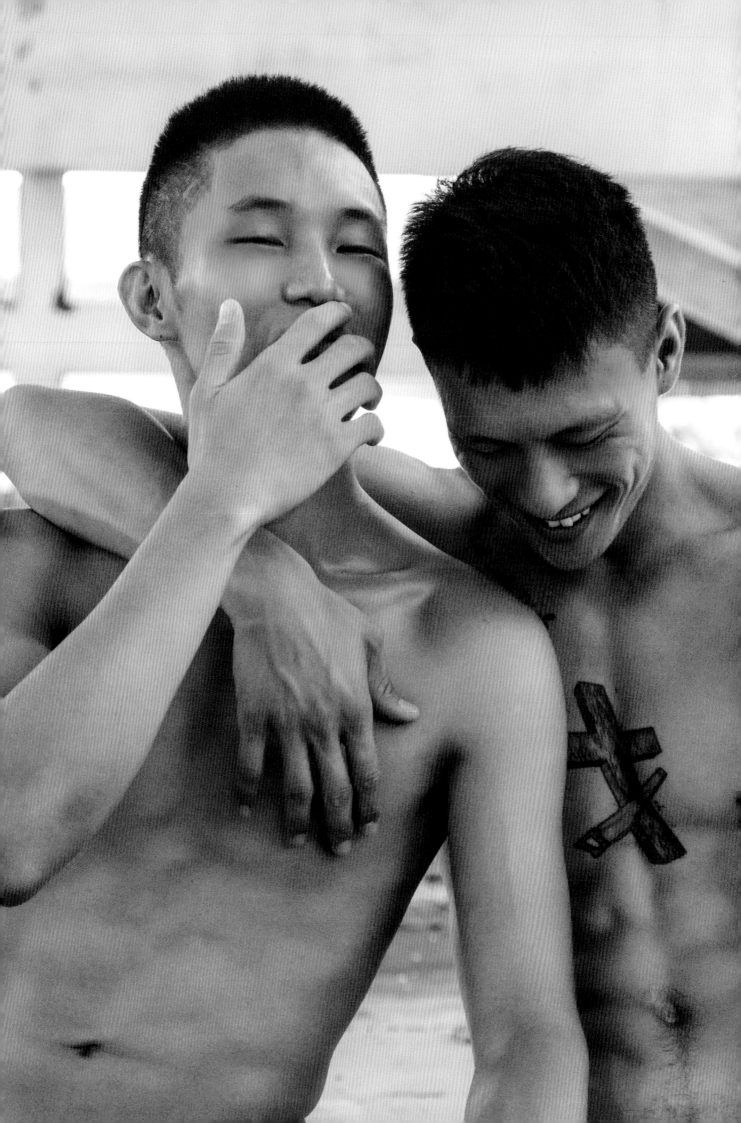

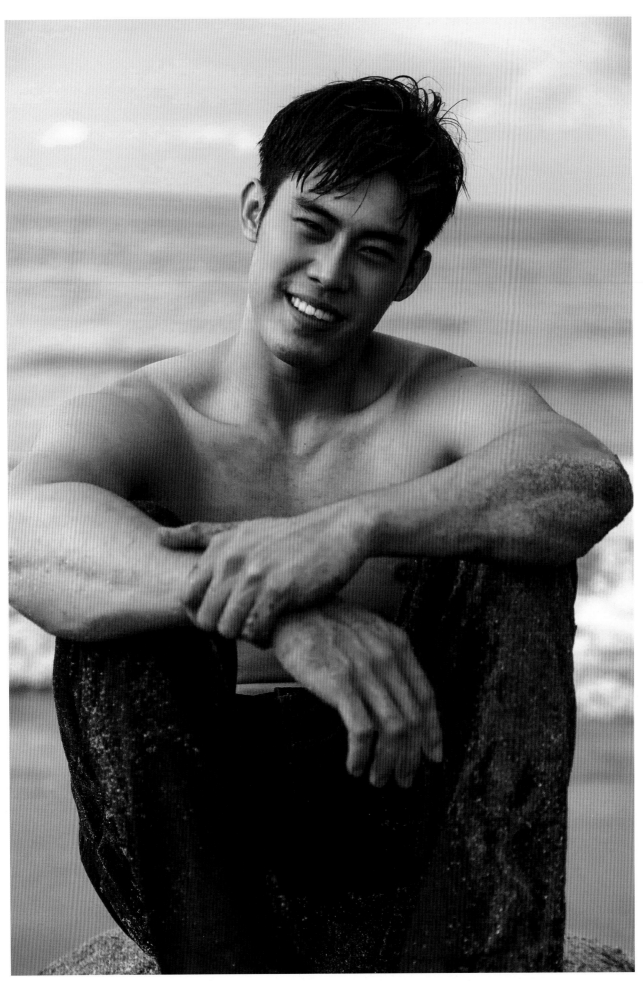

Brad
Taipei, Taiwan
2017

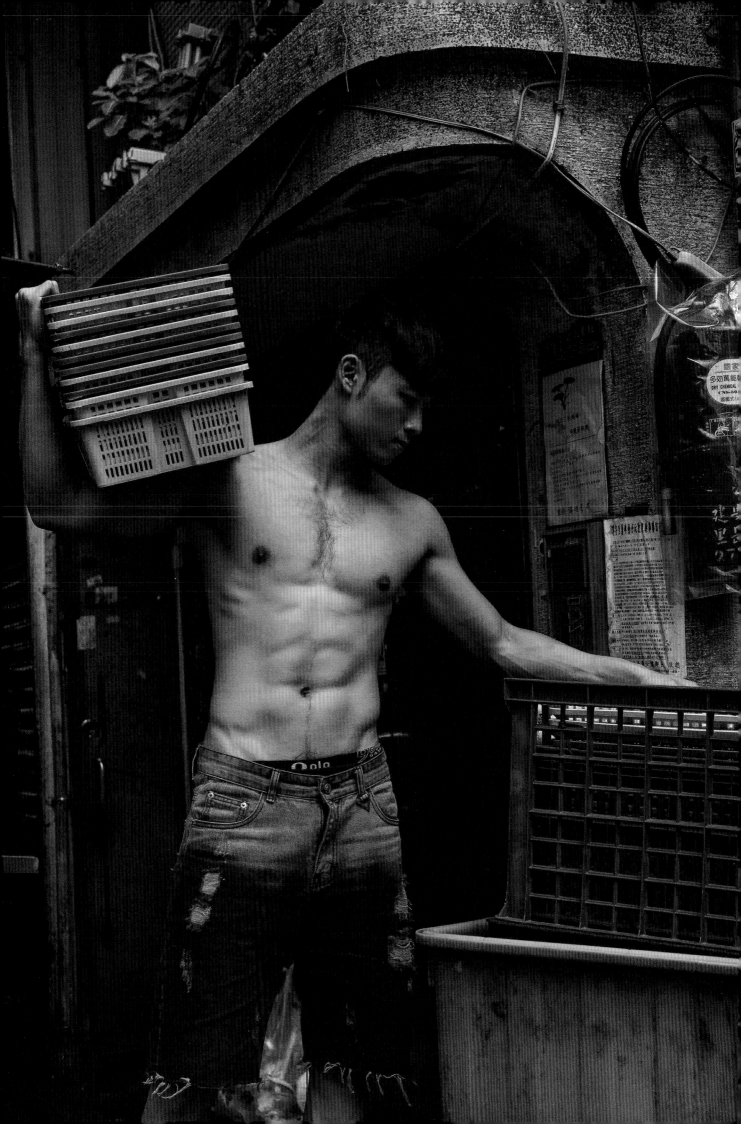

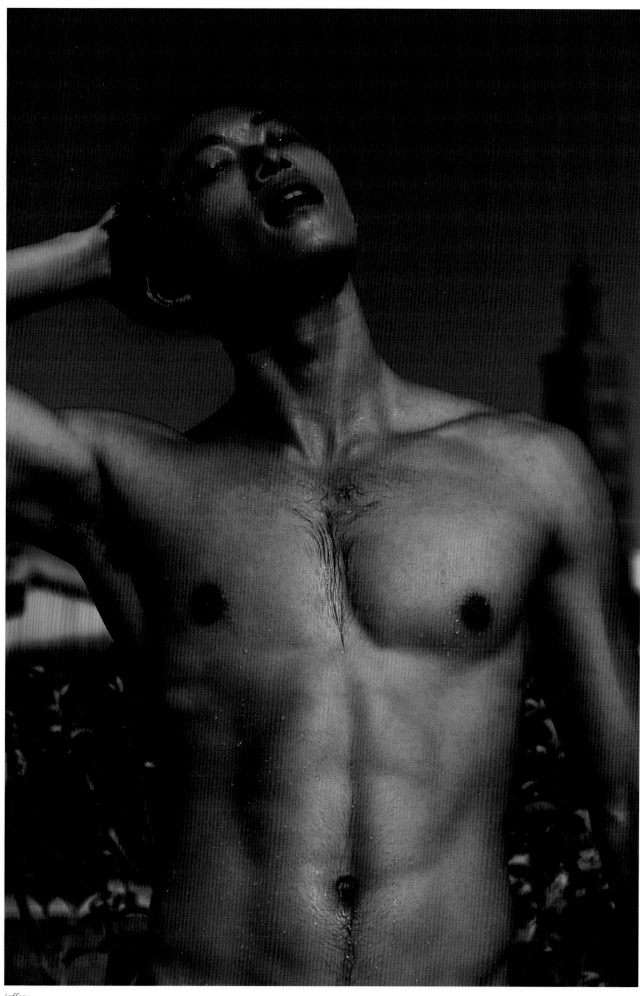

Jaffrey
Taipei, Taiwan
2017

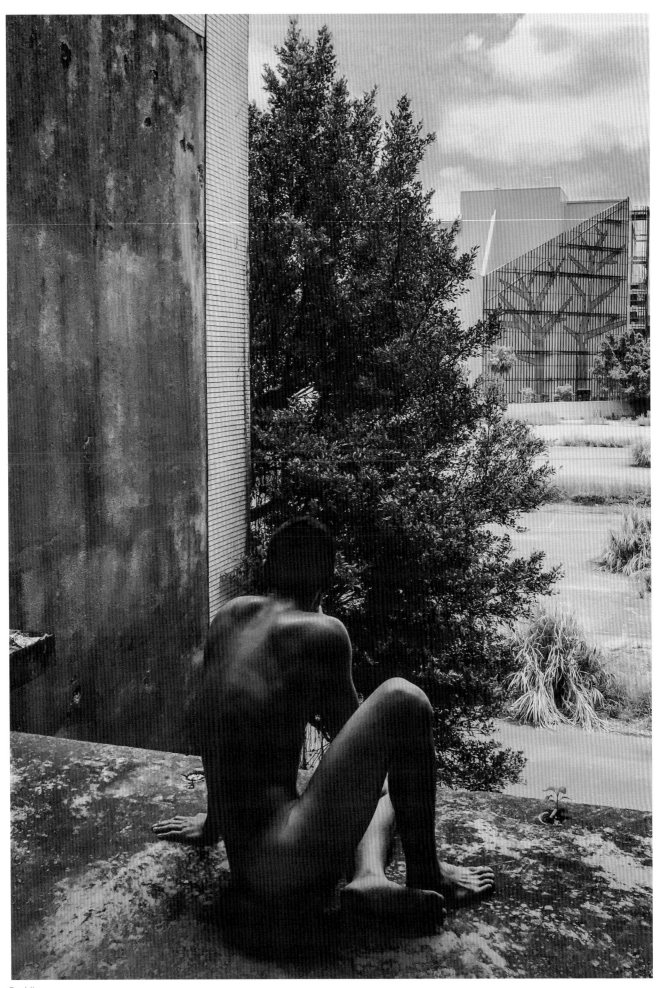

Freddie
Taipei, Taiwan
2017

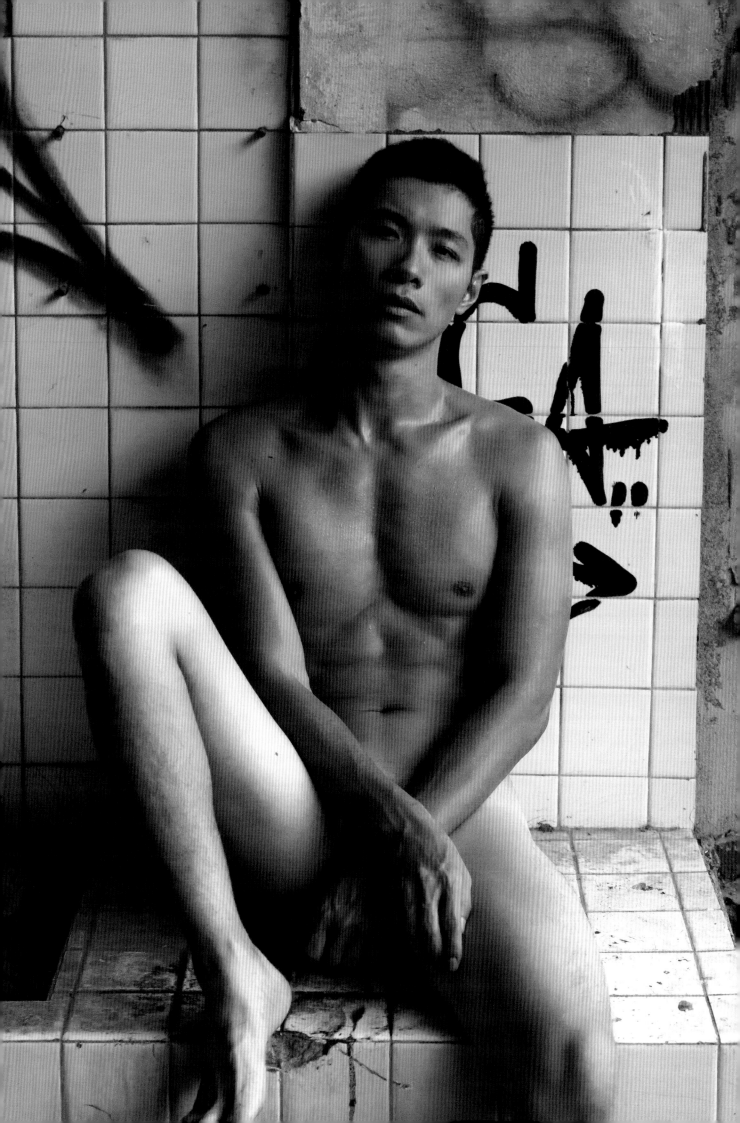

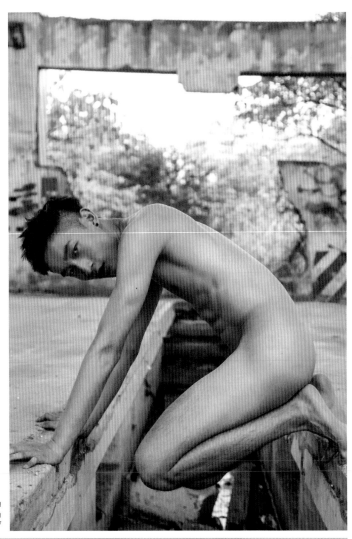

Duncan
Taipei, Taiwan
2017

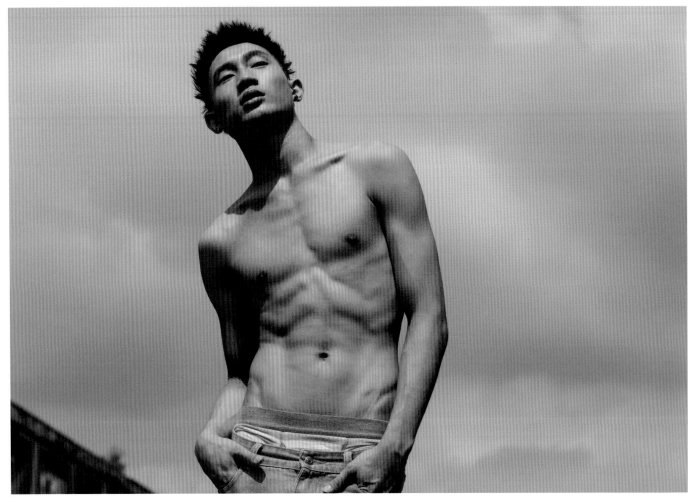

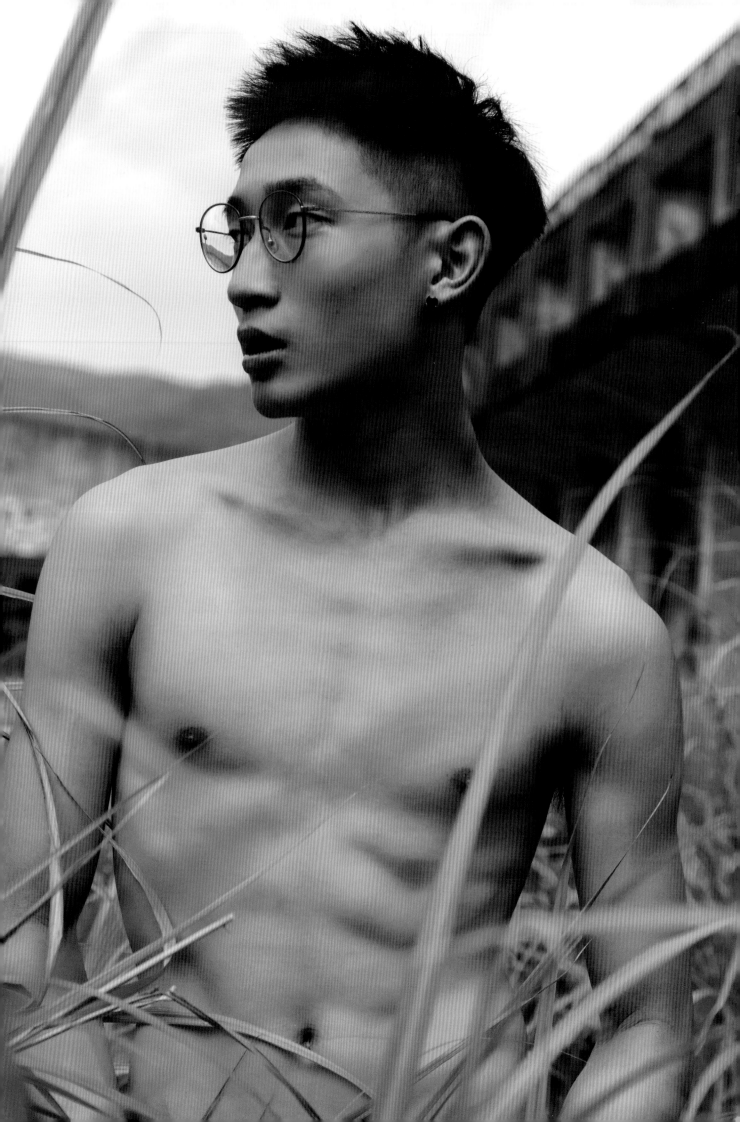

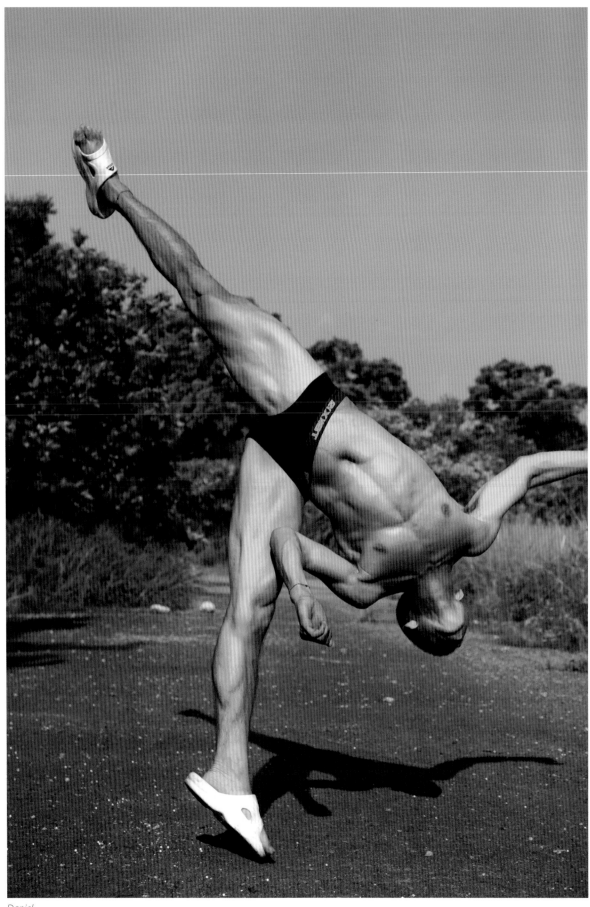

Daniel
Taipei, Taiwan
2017

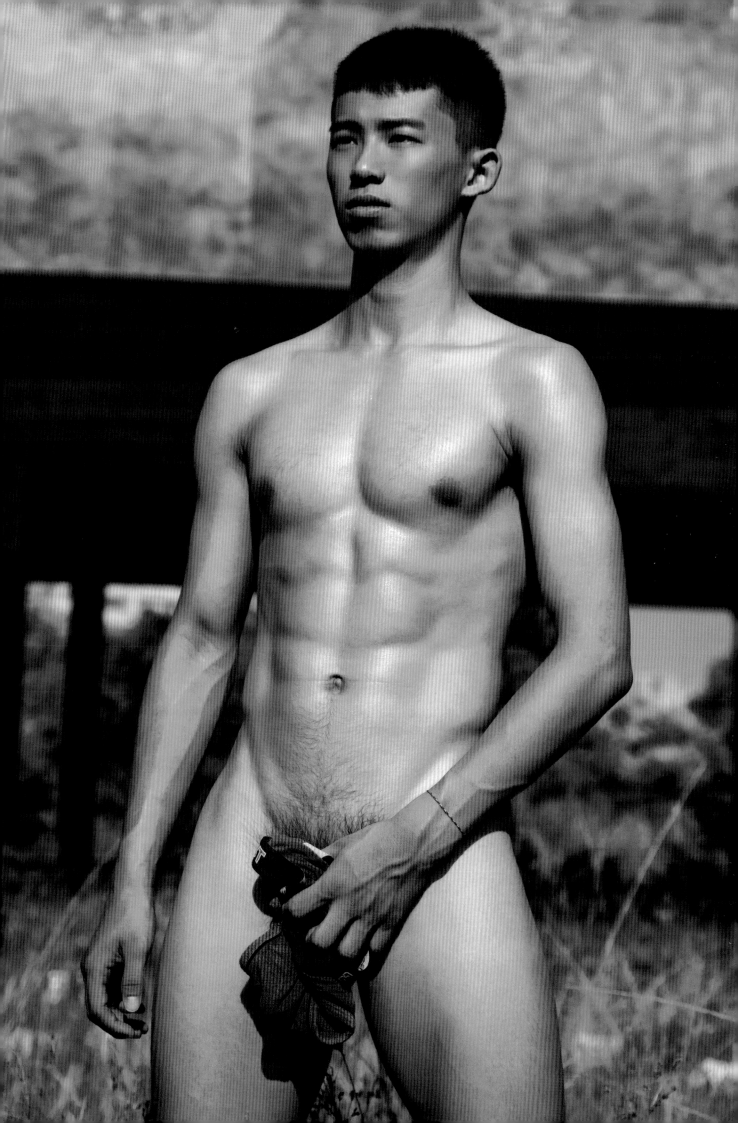

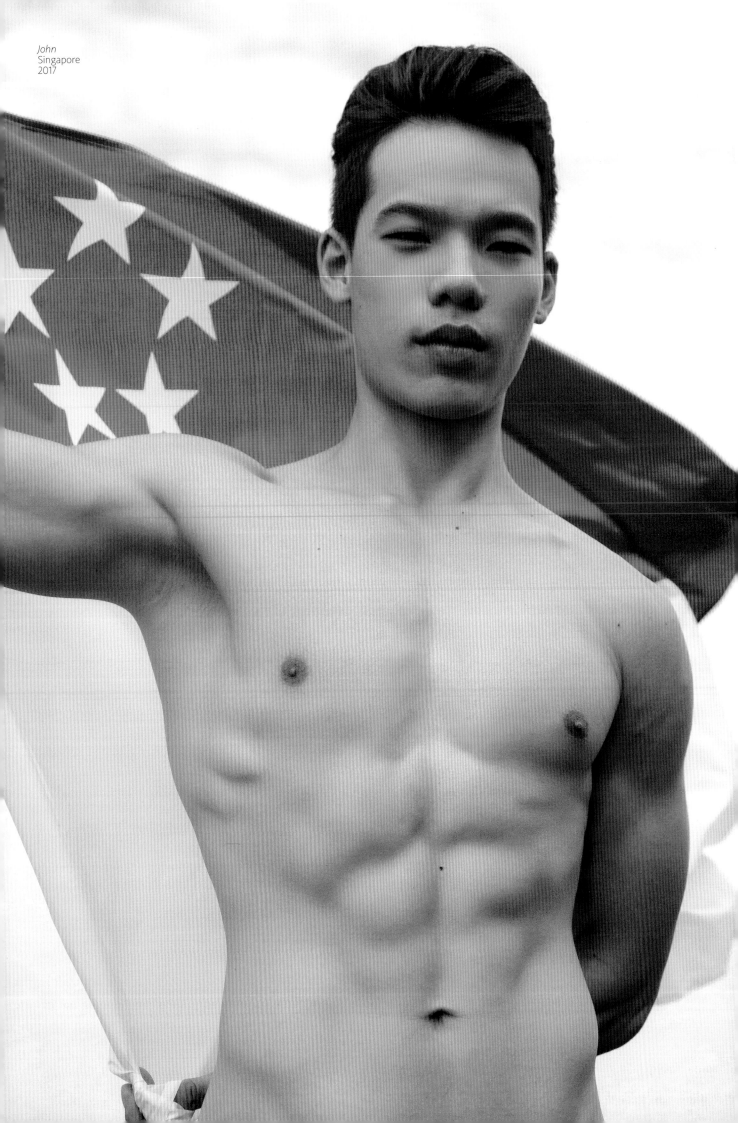

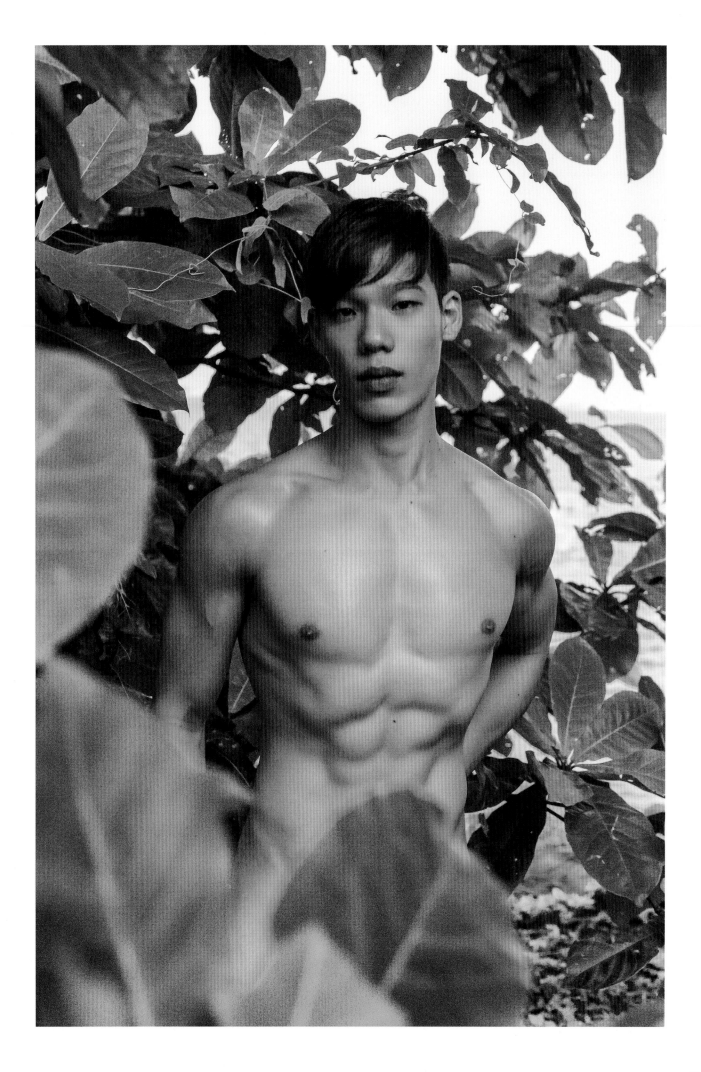

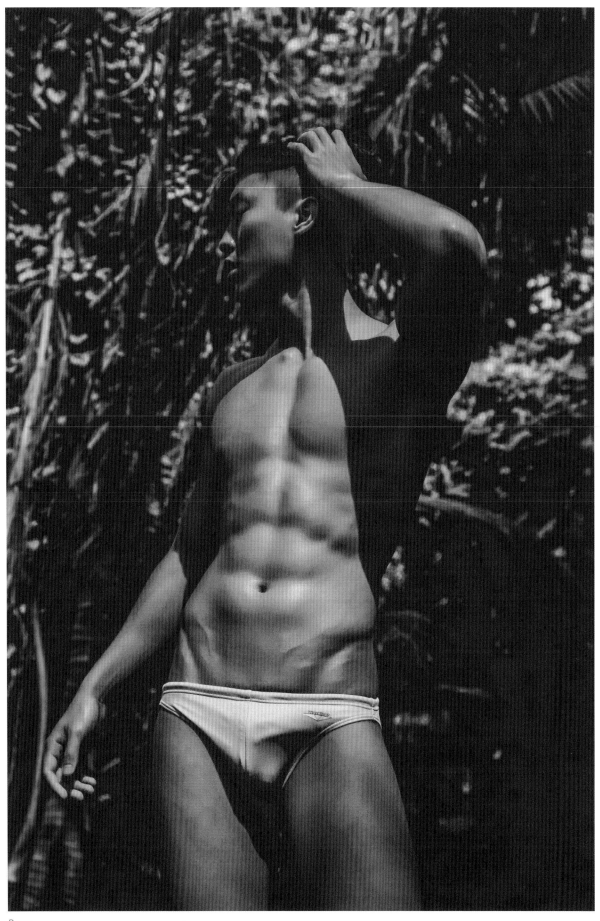

Benny
Singapore
2017

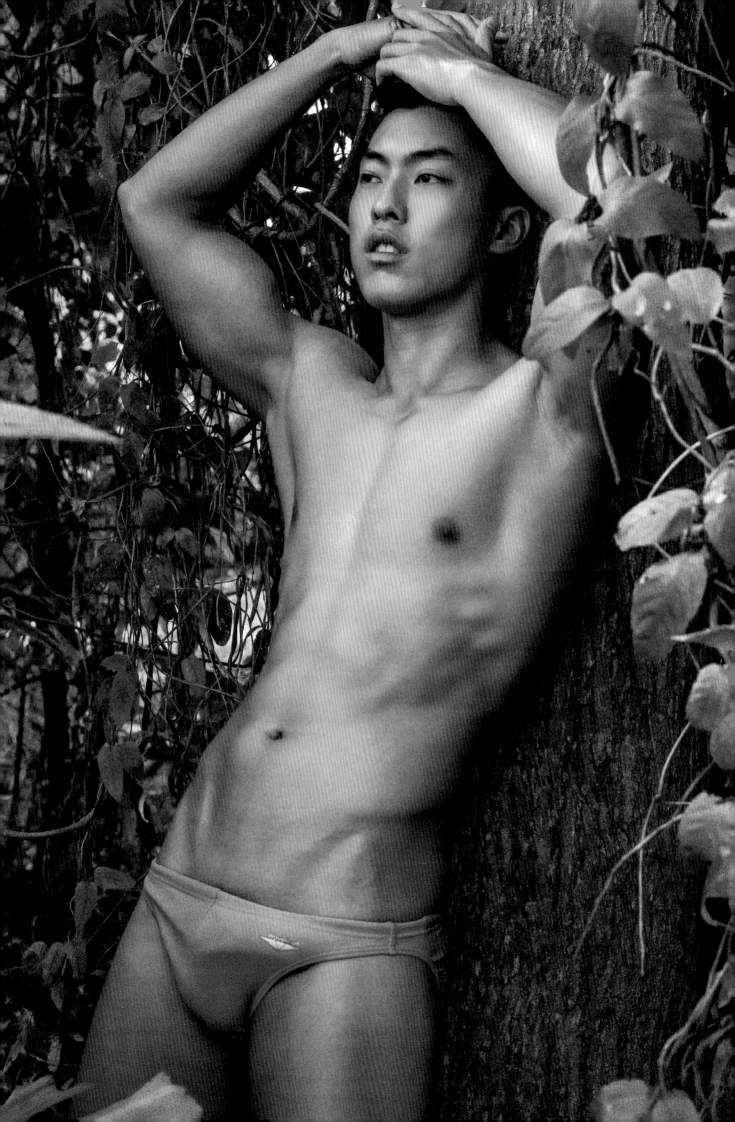

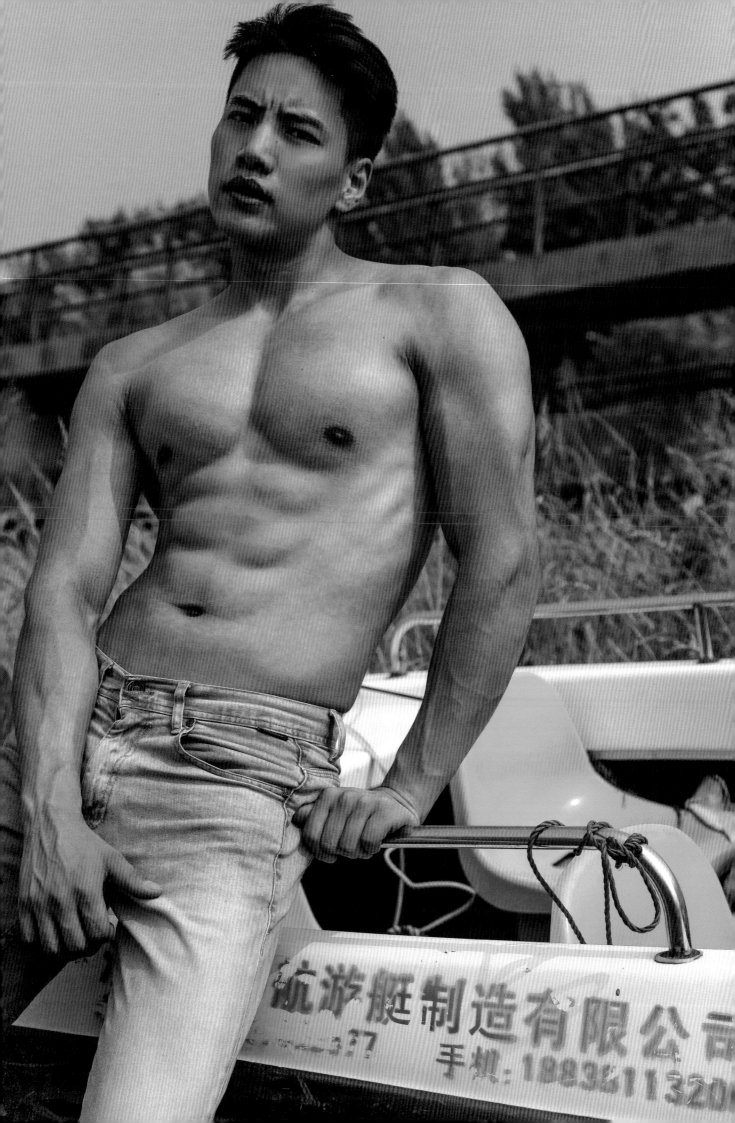

航游艇制造有限公司
377　手机:18996113207

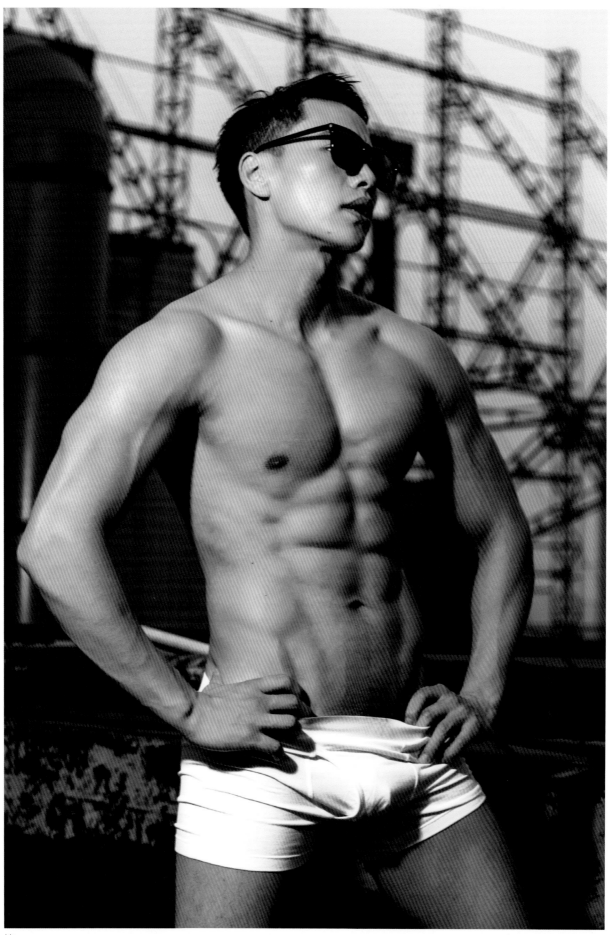

He
Zhengzhou, China
2017

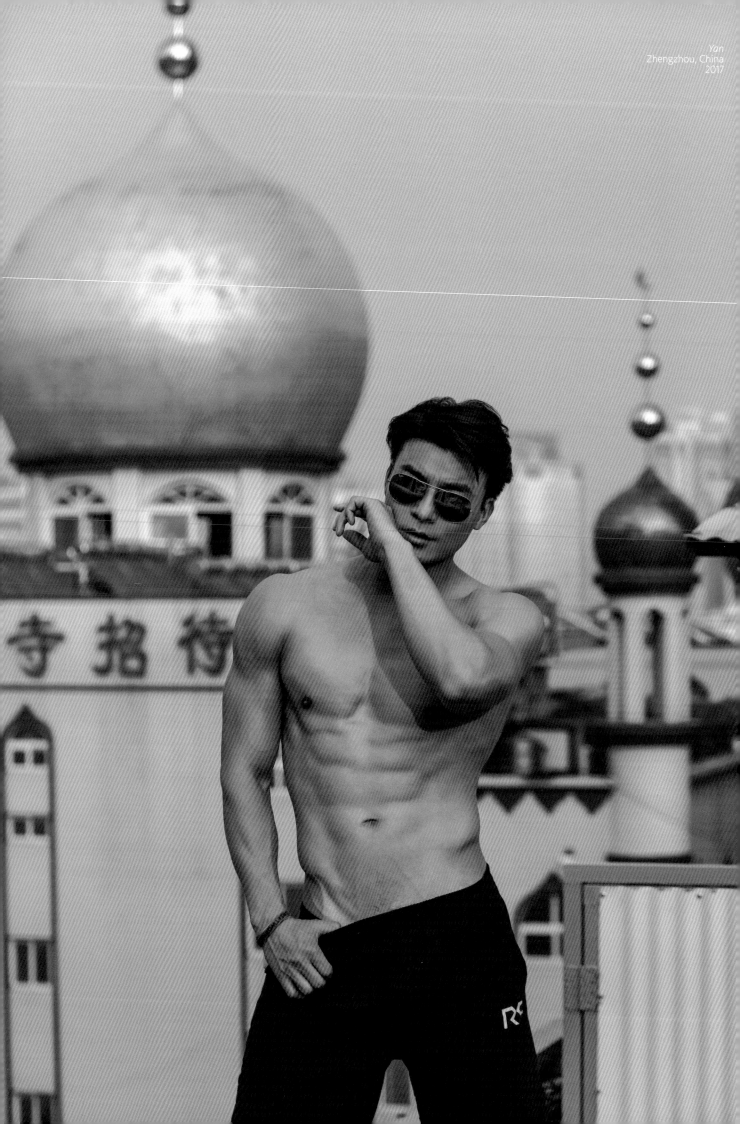

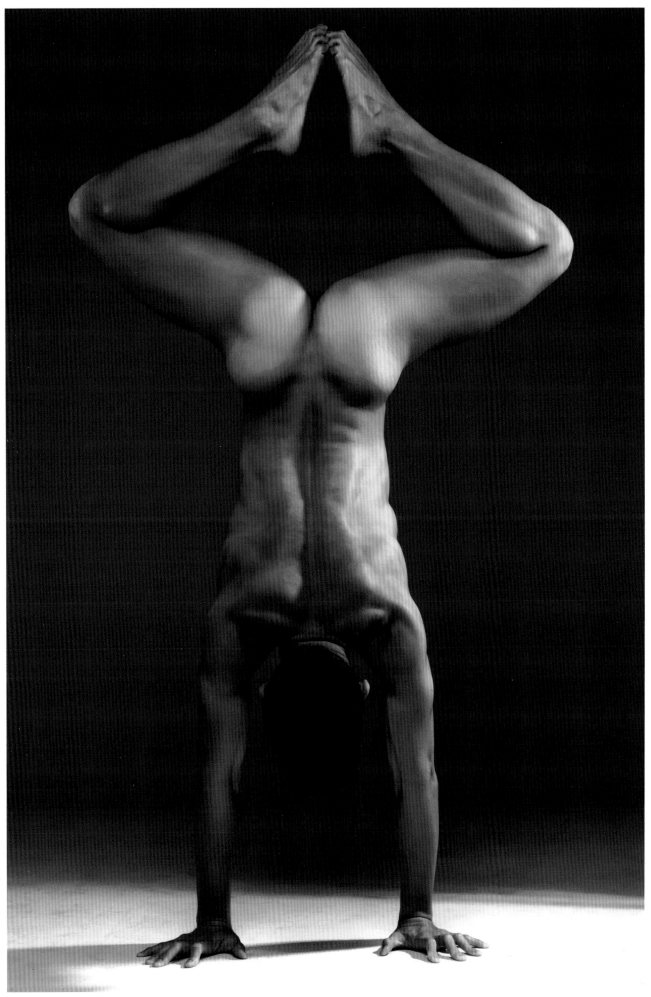

Victor
Zhengzhou, China
2017

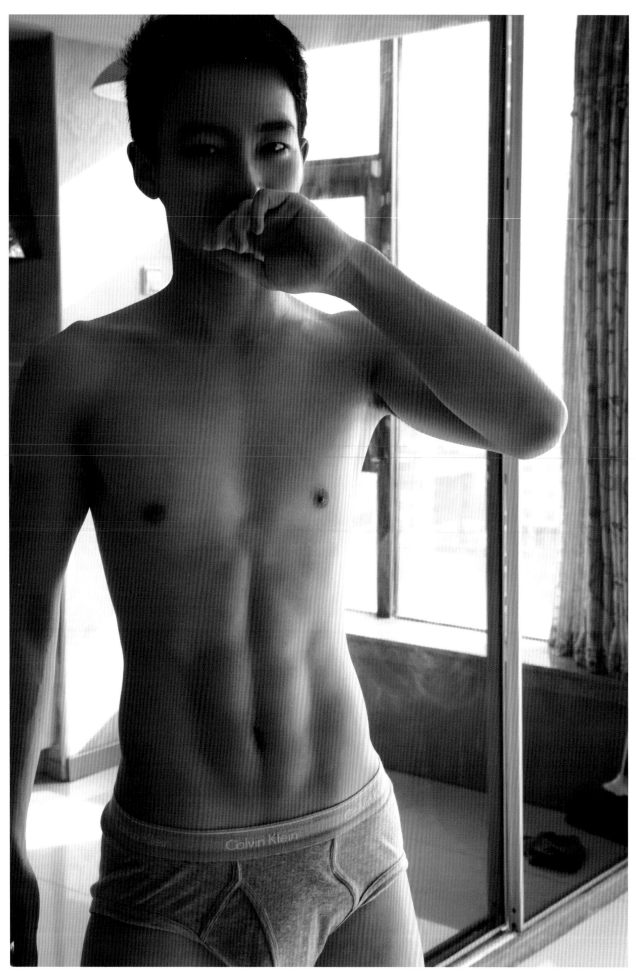

Xavier
Zhengzhou, China
2017

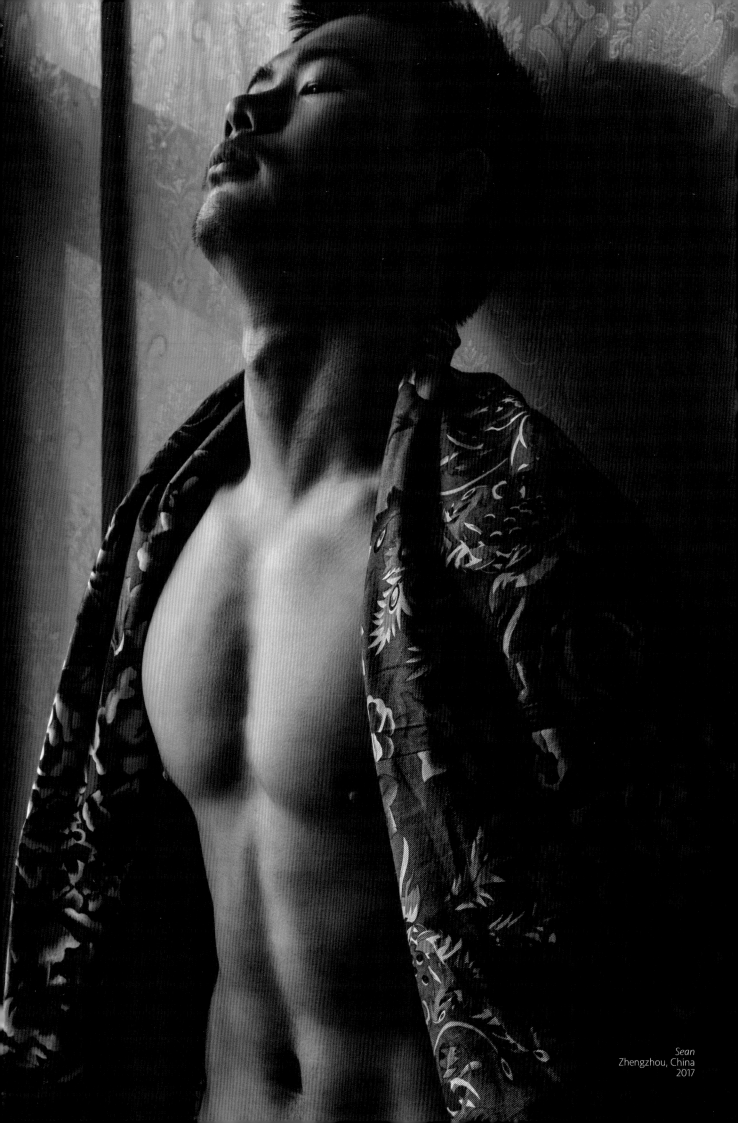

Sean
Zhengzhou, China
2017

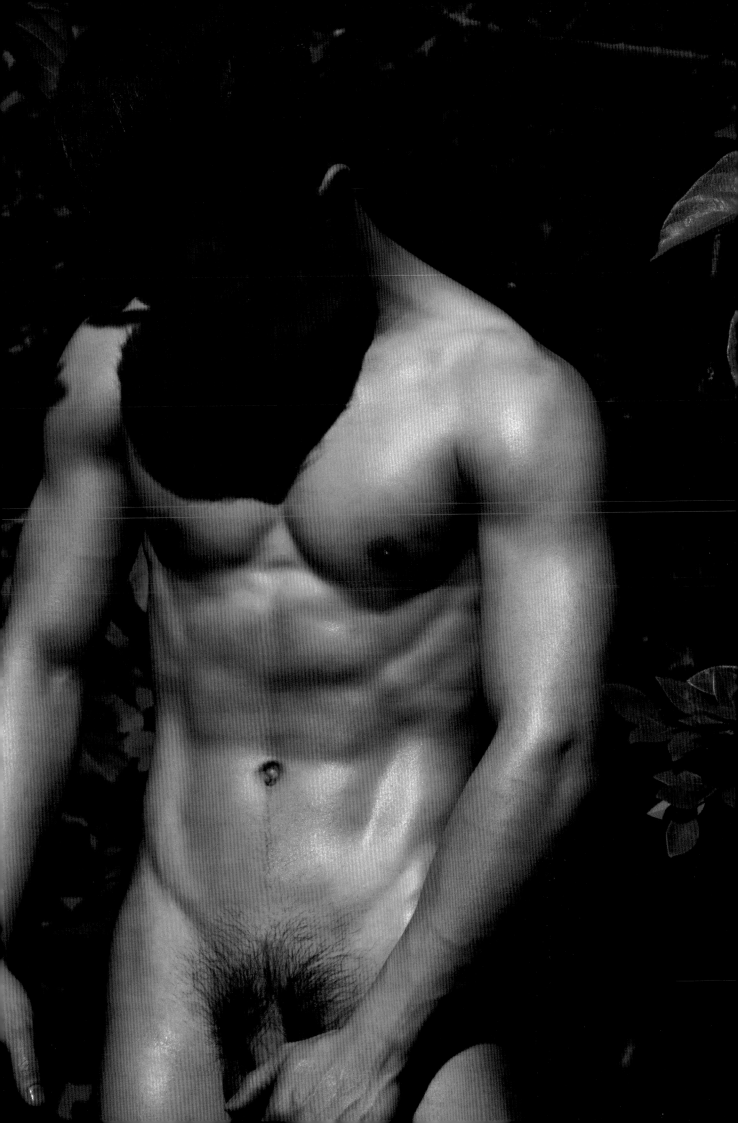

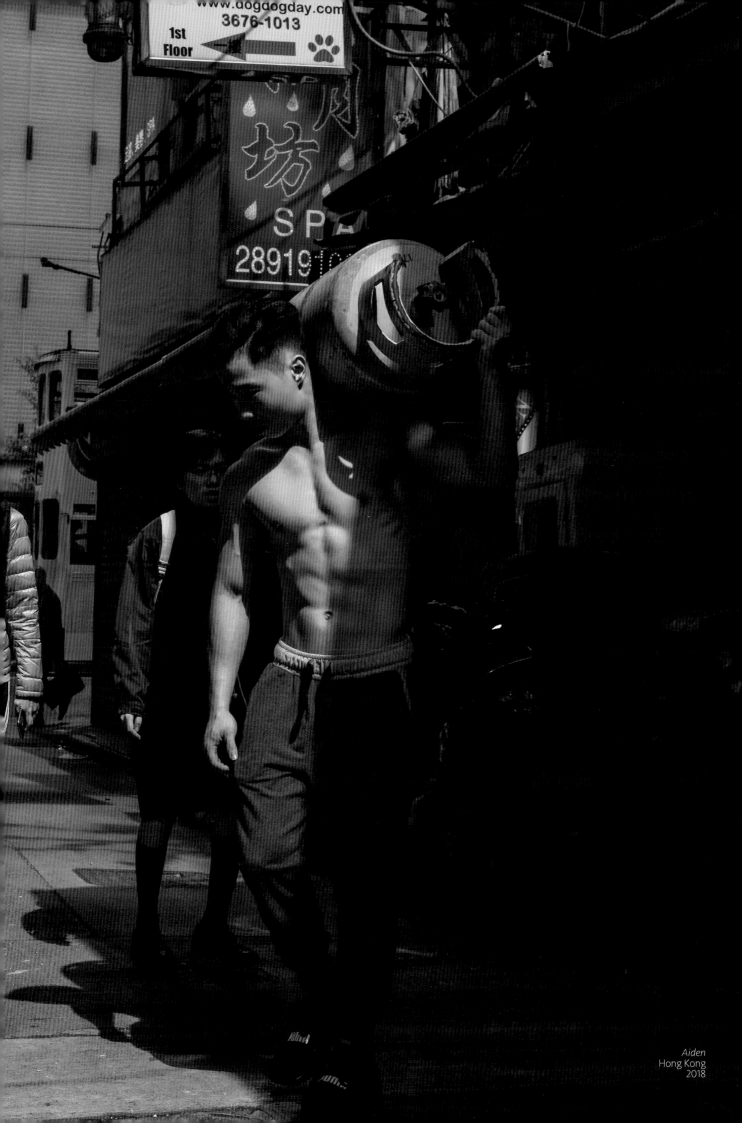

Aiden
Hong Kong
2018

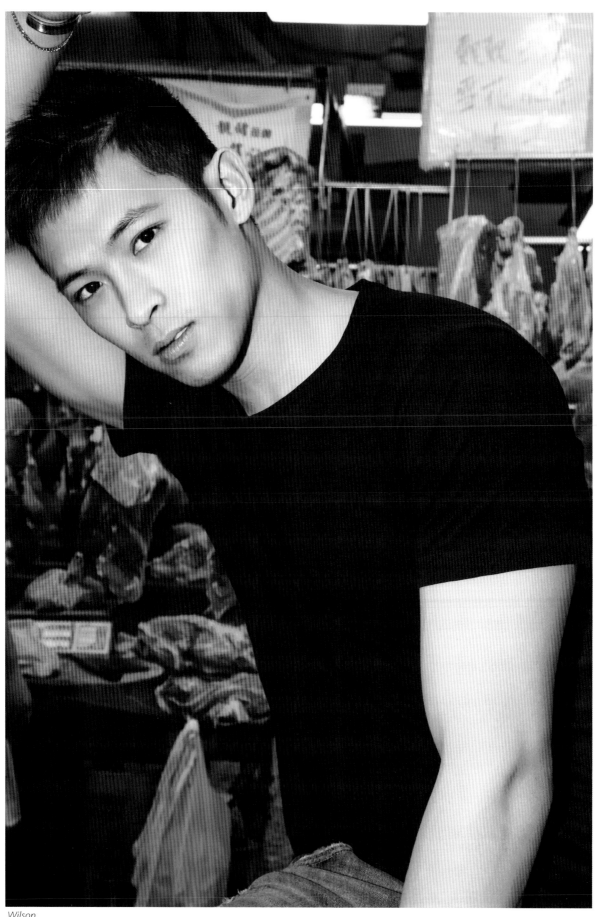

Wilson
Hong Kong
2018

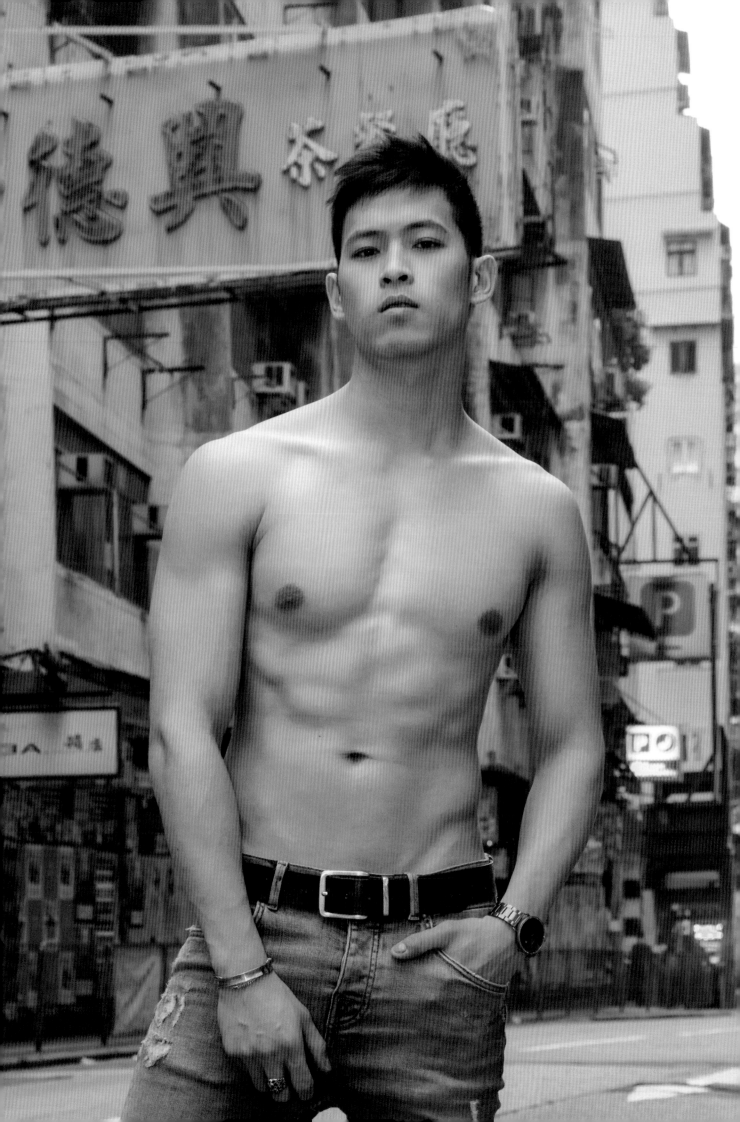

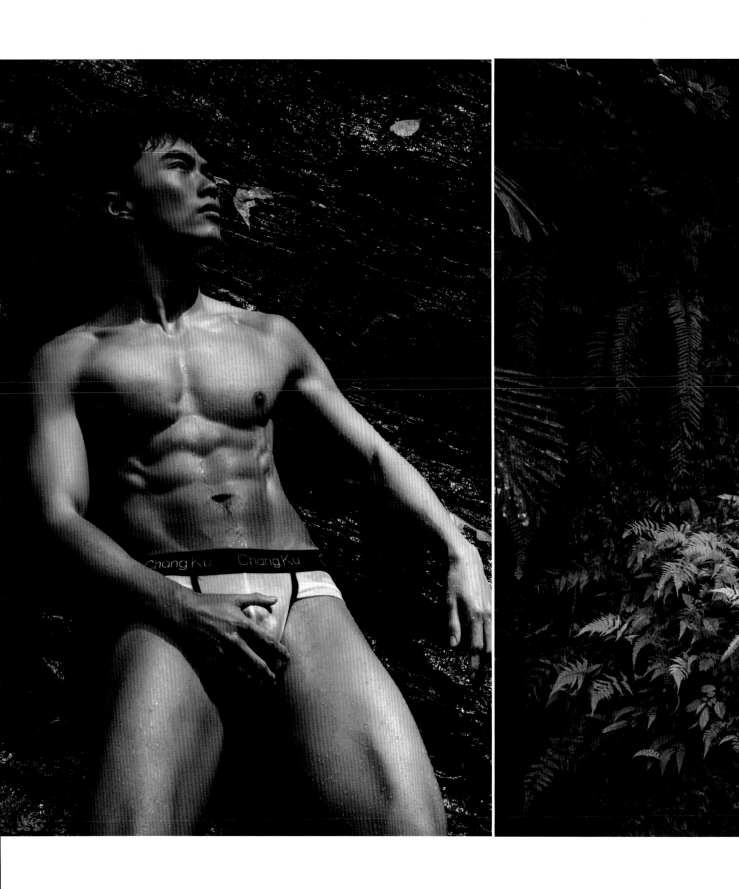

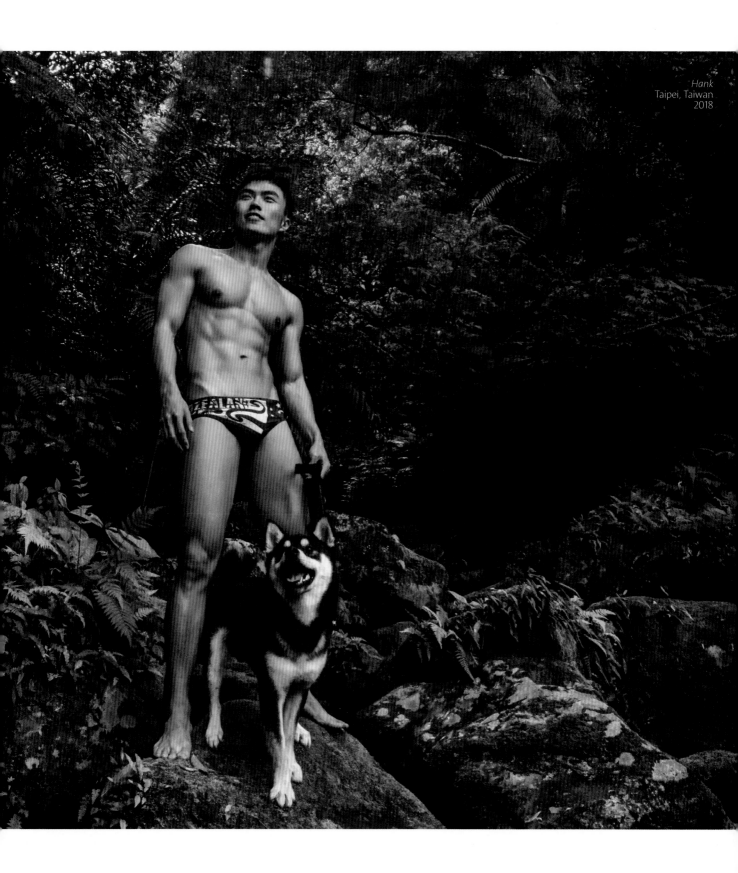

Hank
Taipei, Taiwan
2018

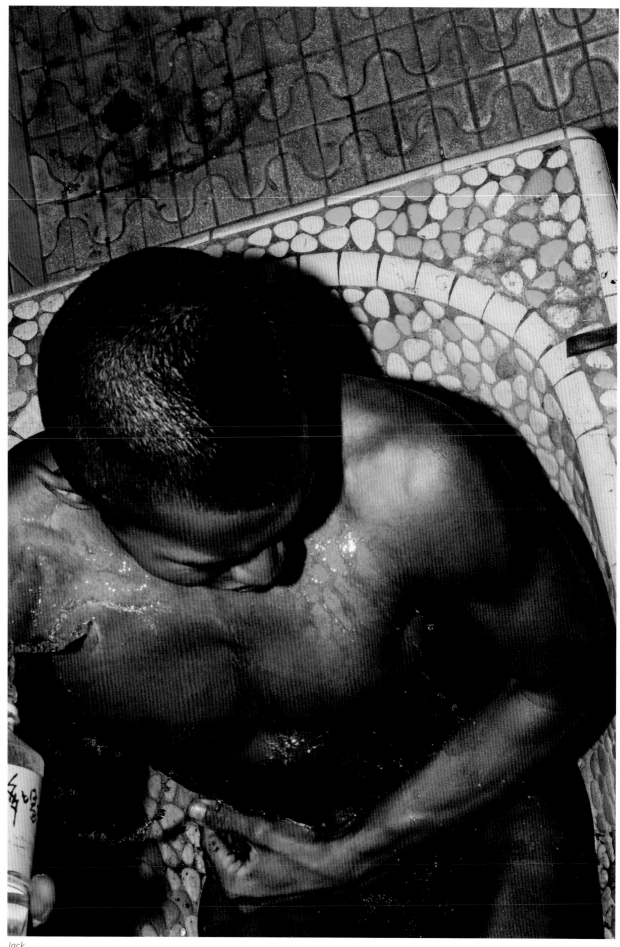

Jack
Taipei, Taiwan
2018

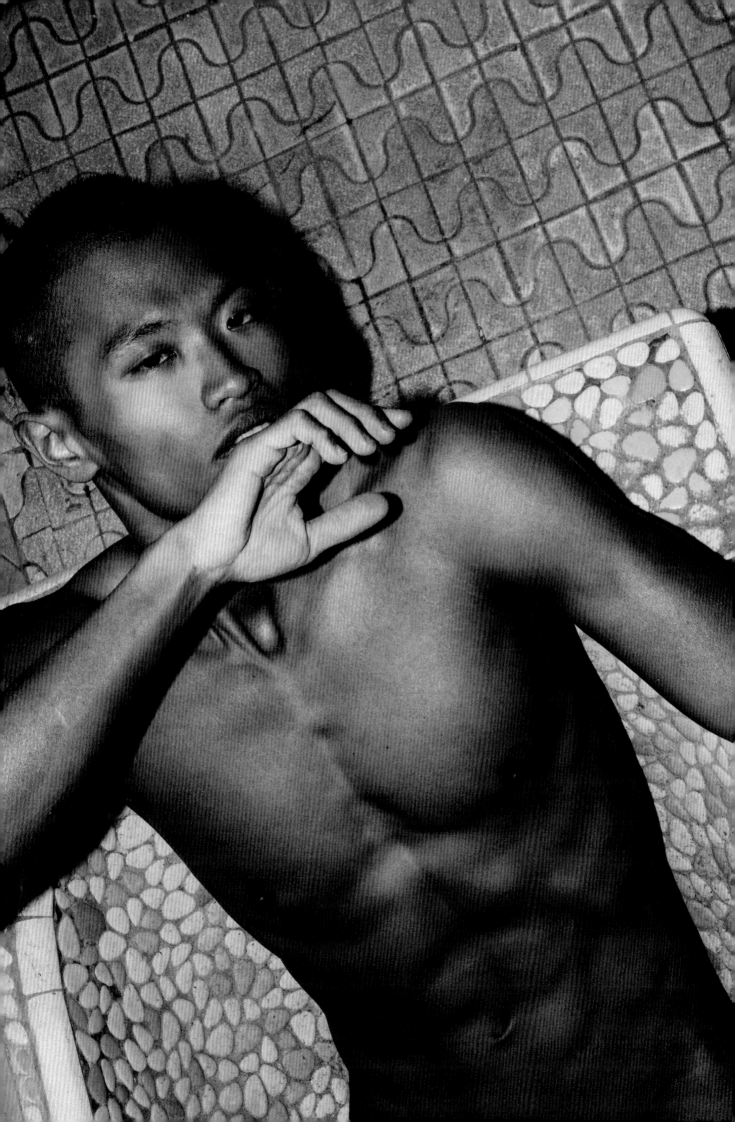

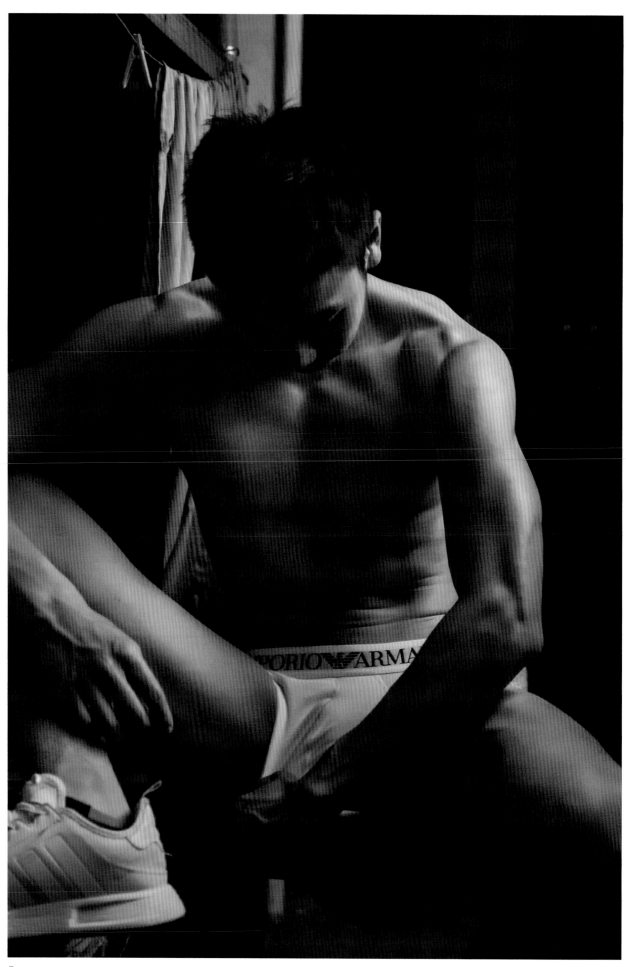

Danny
Taipei, Taiwan
2018

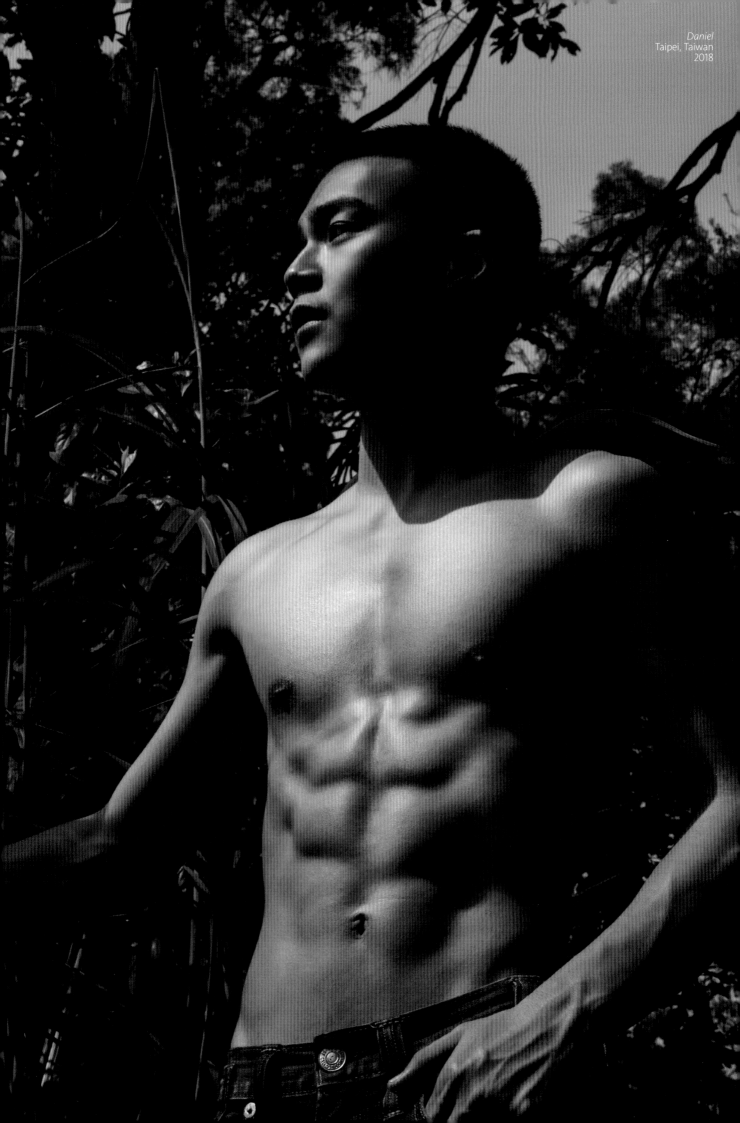

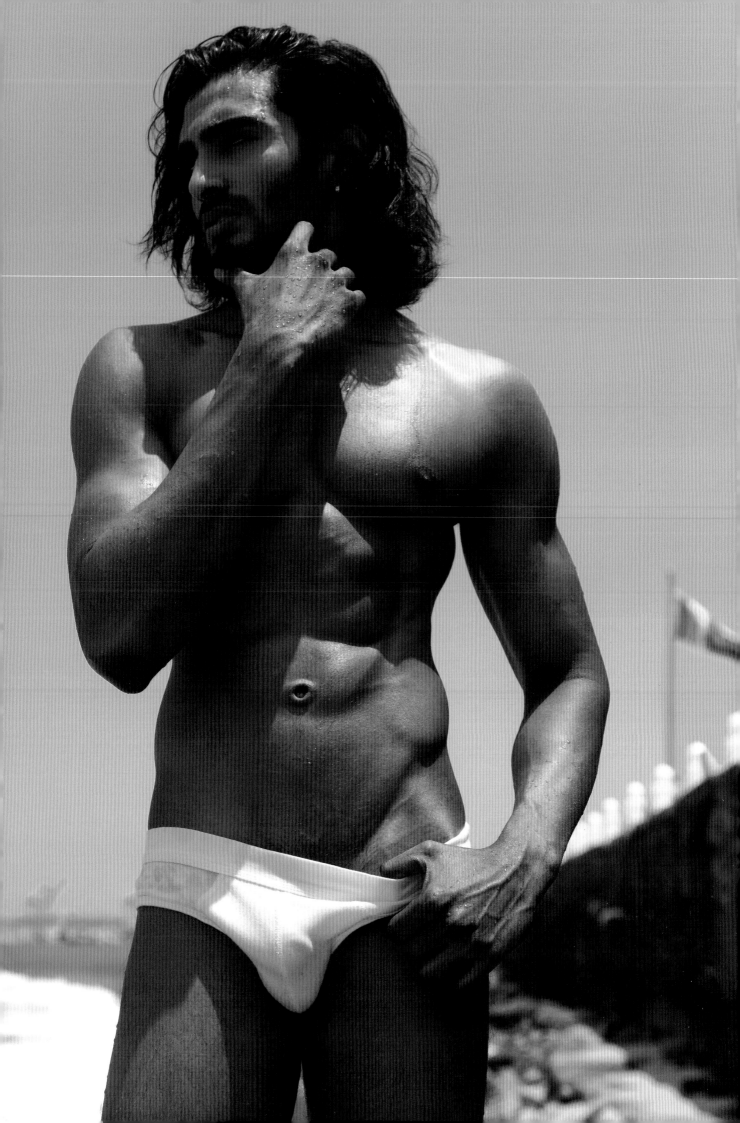

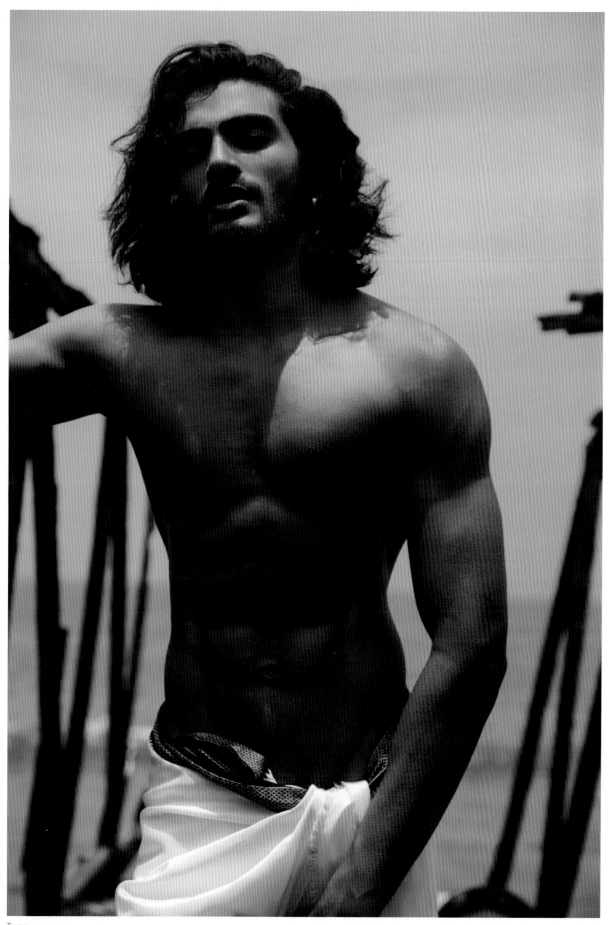

Tymo
Colombo, Sri Lanka
2018

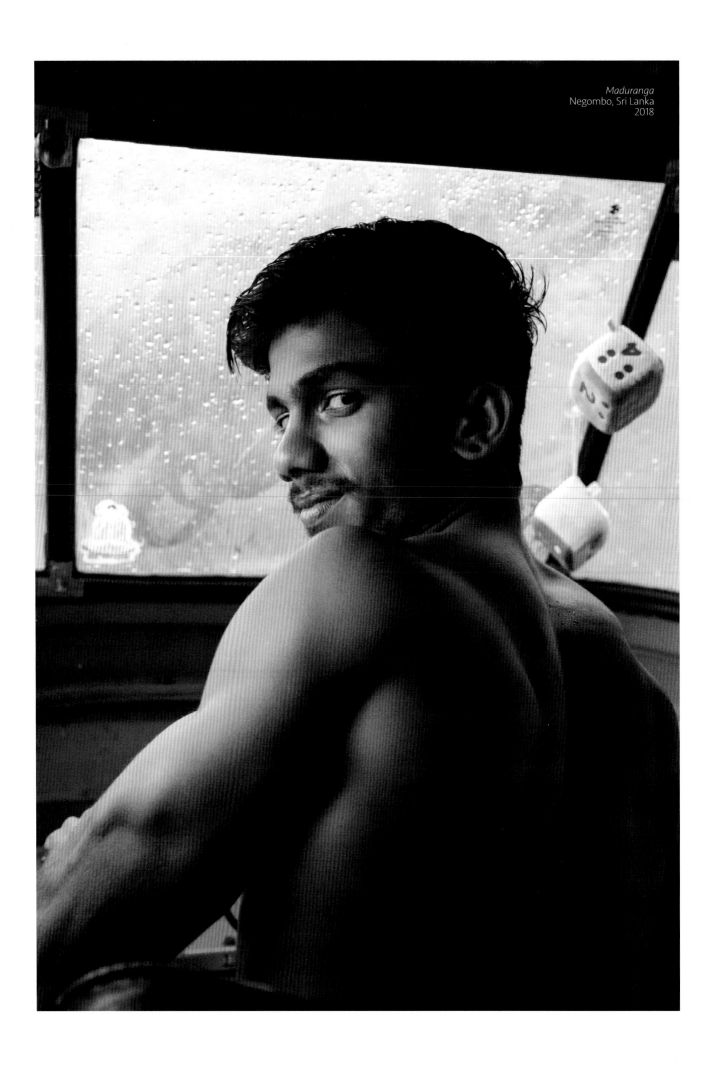

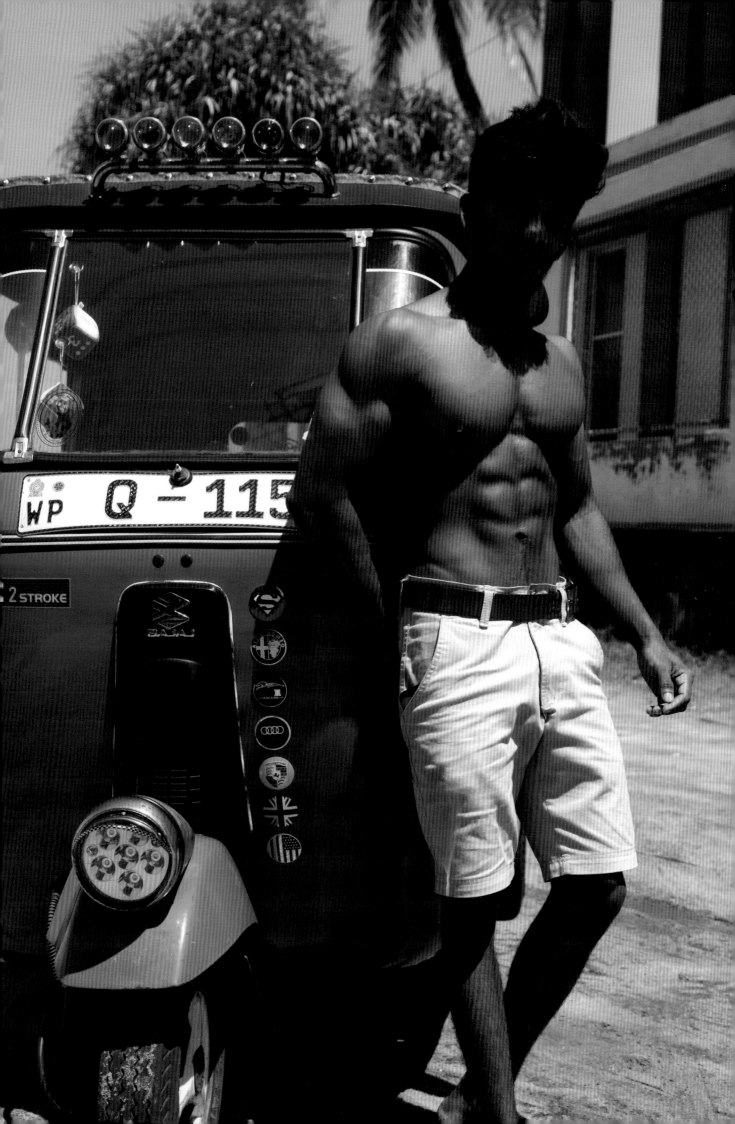

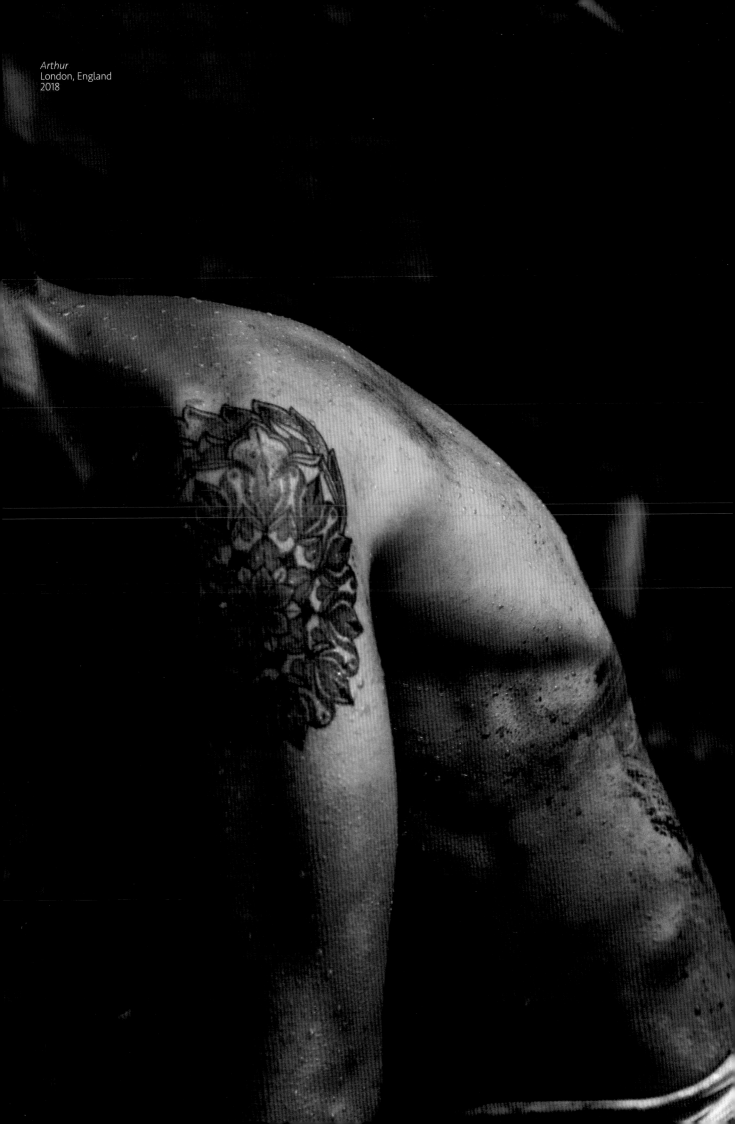

Arthur
London, England
2018

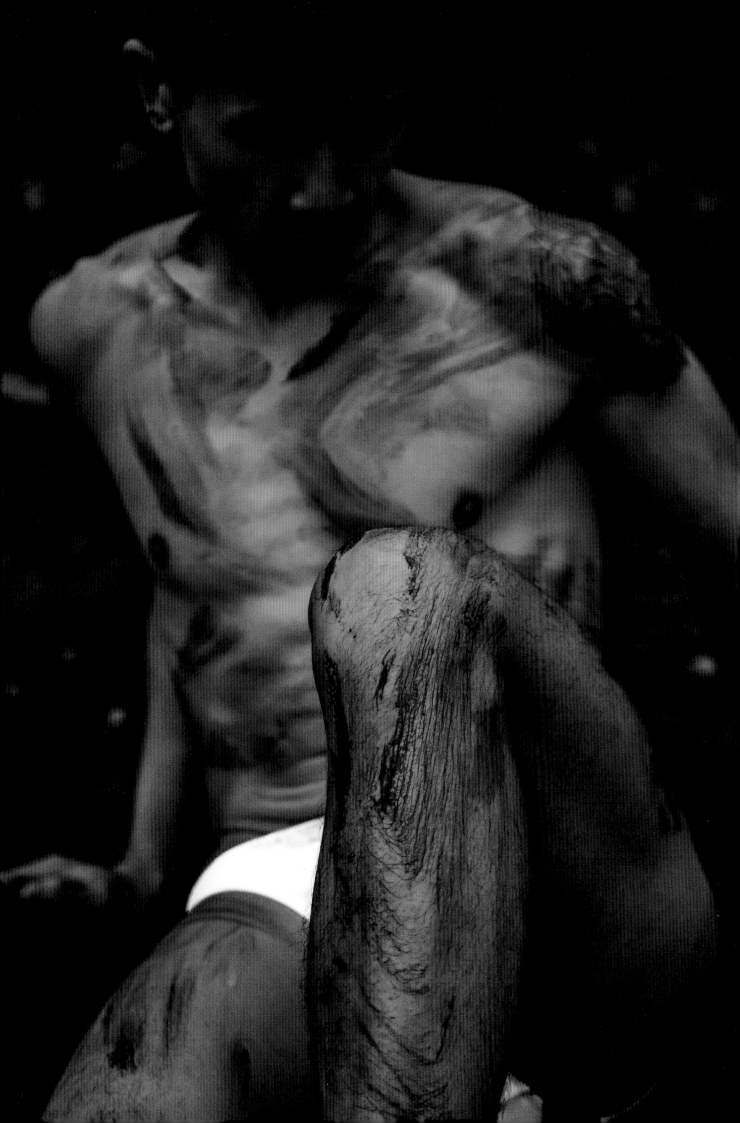

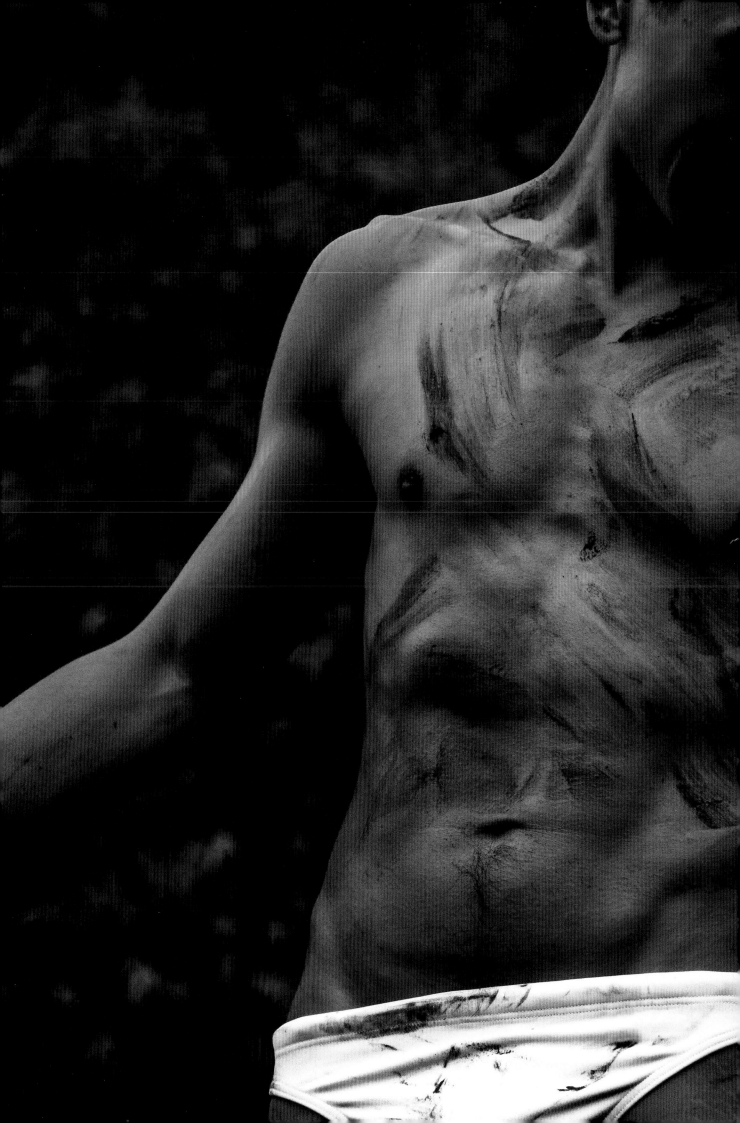

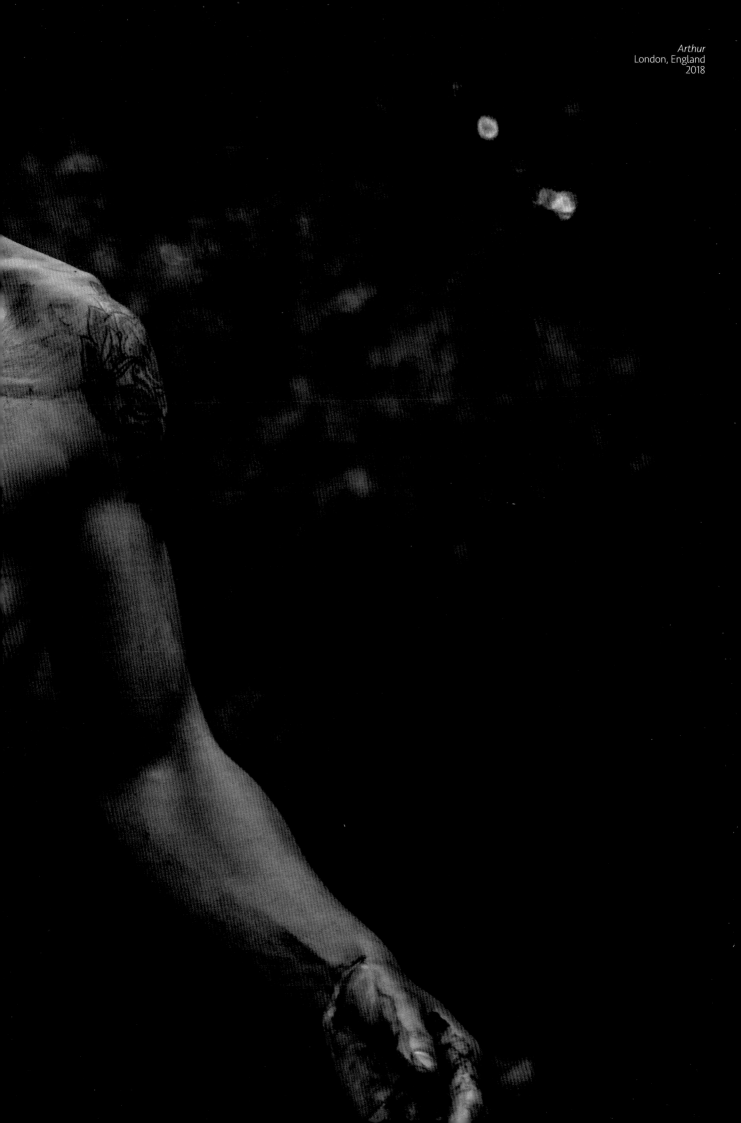

Arthur
London, England
2018

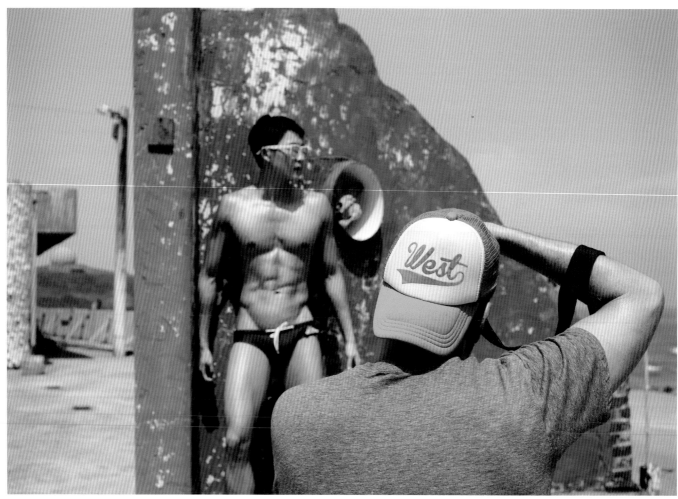

Behind the scenes:
Gino
Taipei, Taiwan
2016

AMP
Copyright © 2018 West Phillips
westphillips.com

Design and layout by Johnny Lu Studio
johnny-lu.com

ISBN 978-1-7320888-2-5

Printed and bound in China.

in partnership with

IMPERIAL COMMERCE LTD

imperialcommerce.co.uk